TALK BACK

THE BUBBLE PROJECT

Ji Lee

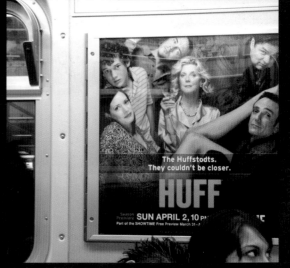

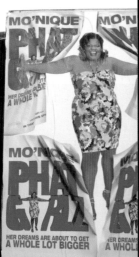
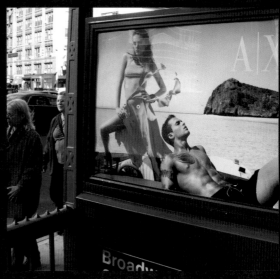
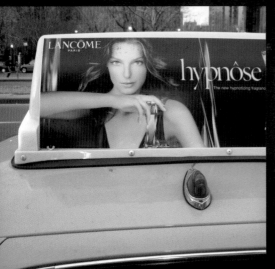
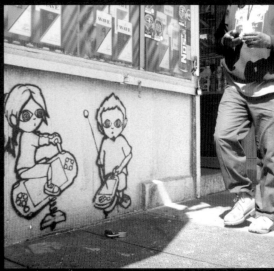

ADVERTISING

OUR COMMUNAL SPACES ARE OVERRUN WITH ADS. BUILDINGS, BUS STOPS, PHONE BOOTHS AND SUBWAYS SCREAM ONE MESSAGE AFTER ANOTHER AT US.

ONCE CONSIDERED "PUBLIC," THESE SPACES ARE INCREASINGLY BEING SEIZED BY CORPORATIONS TO PROPAGATE THEIR MESSAGES SOLELY IN THE INTEREST OF PROFIT. WE, THE PUBLIC, ARE BOTH TARGET AND VICTIM OF THIS MEDIA ATTACK.

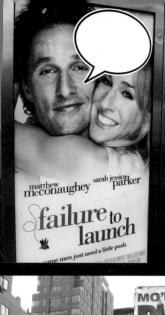

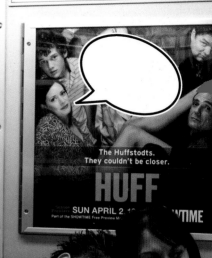
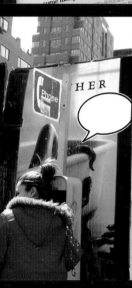
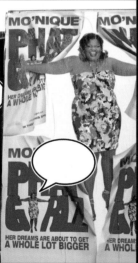

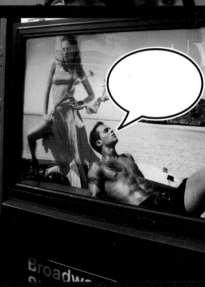
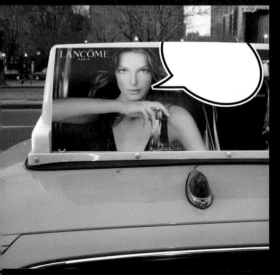
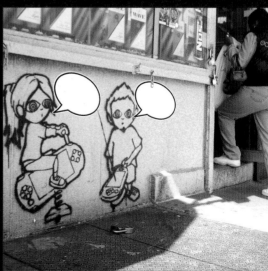

THE BUBBLE PROJECT

OVER 30,000 BLANK BUBBLE
STICKERS WERE PRINTED.

THEY ARE CONTINUALLY PLACED
ON STREET ADVERTISING, INVITING
PASSERSBY TO FILL THEM IN. THE
RESULTS ARE LATER PHOTOGRAPHED.

THE FOLLOWING IS A COLLECTION
OF SOME OF THE BEST BUBBLES,
SO FAR.

CONTENTS

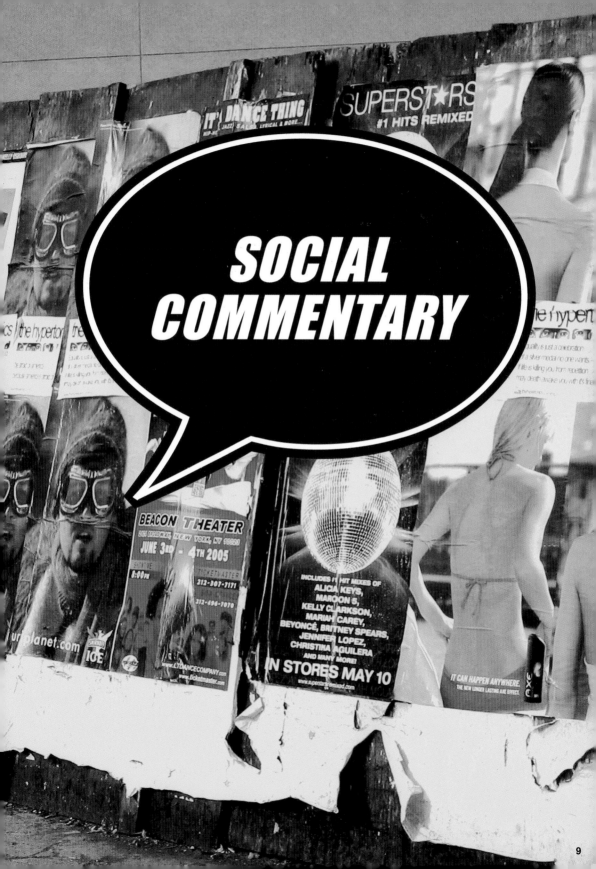

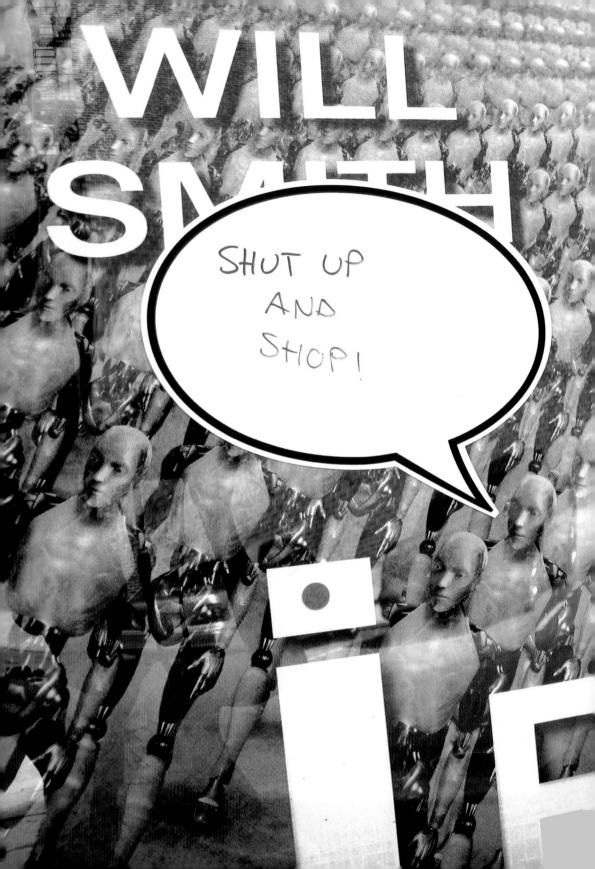

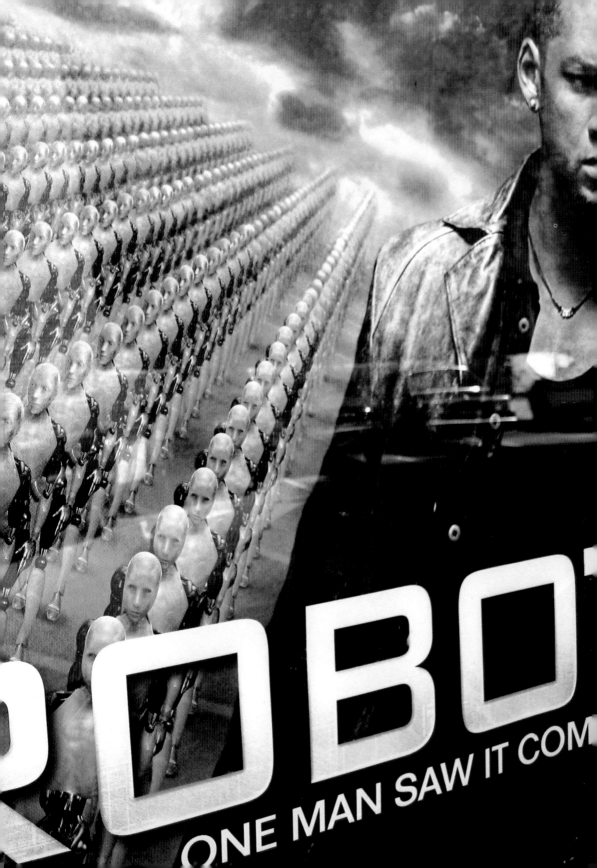

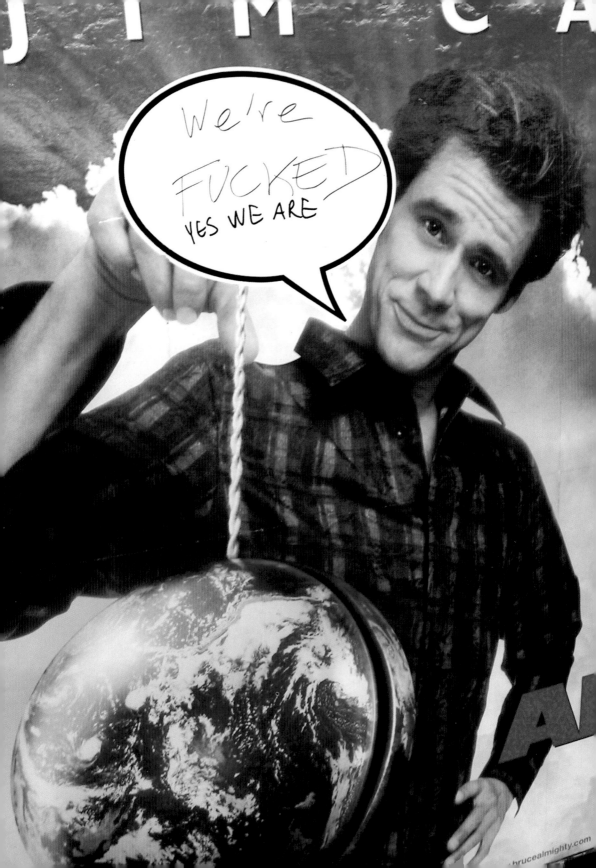

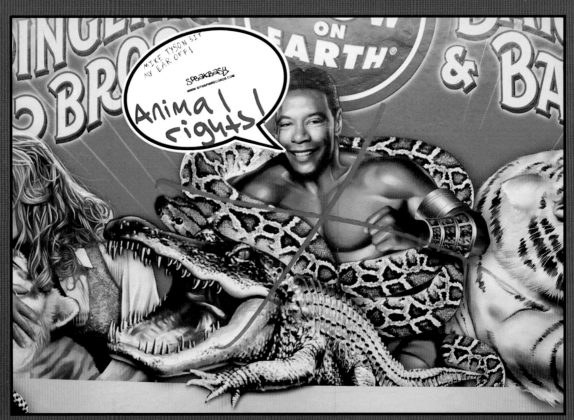
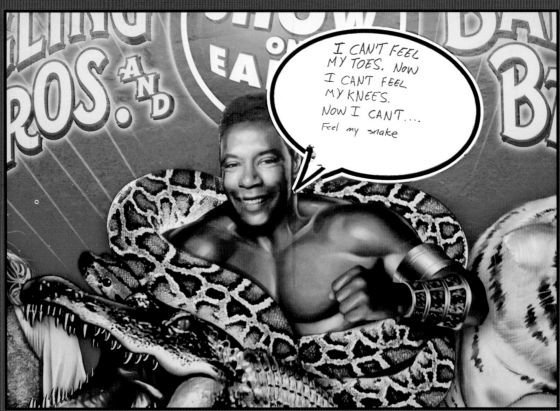

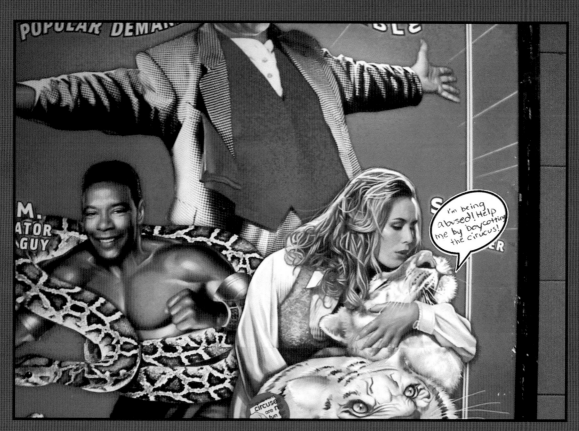

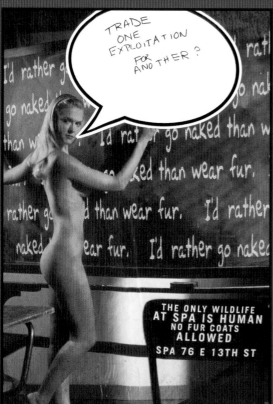

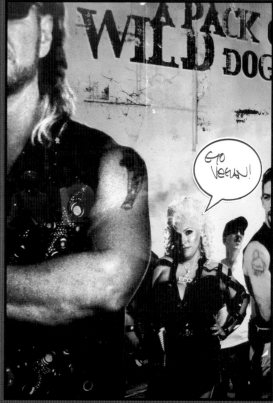

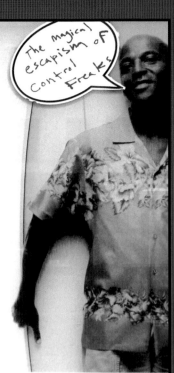

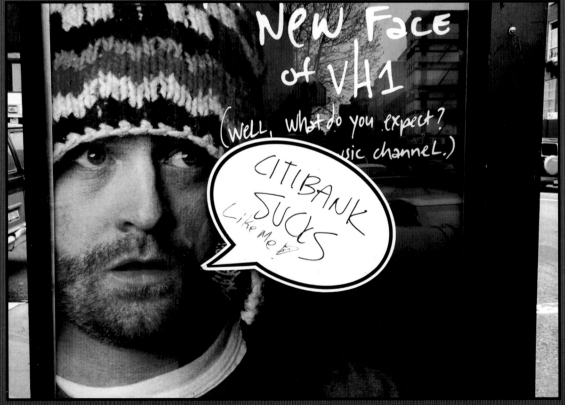

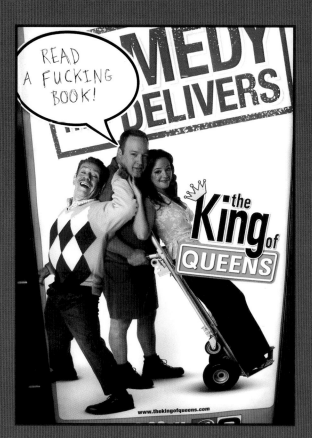

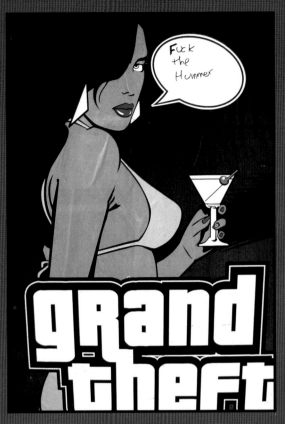

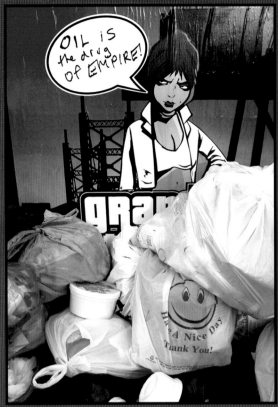

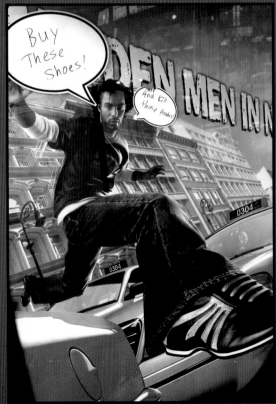

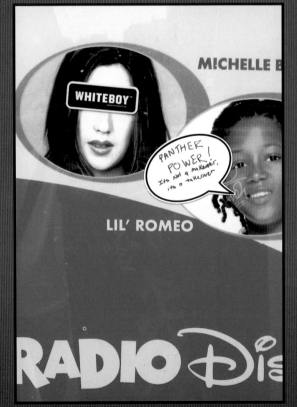

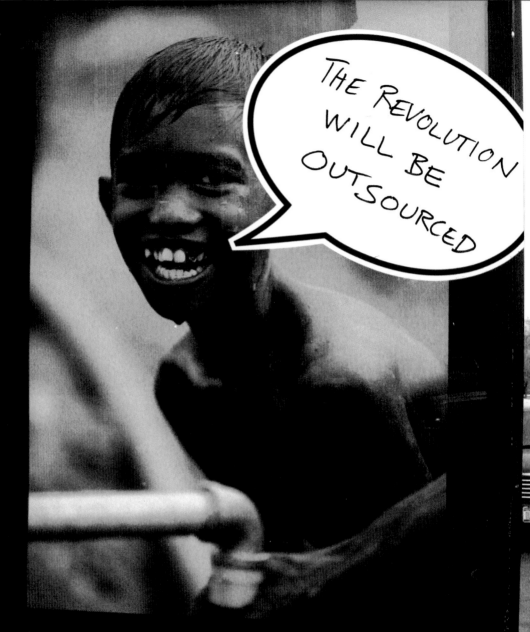

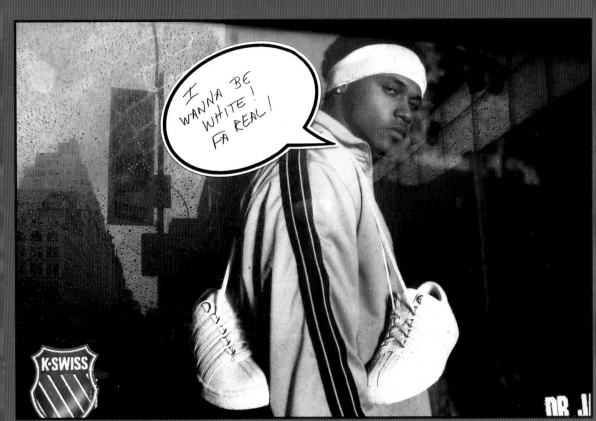

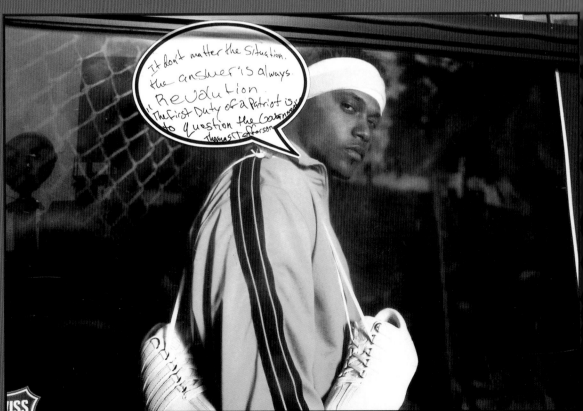

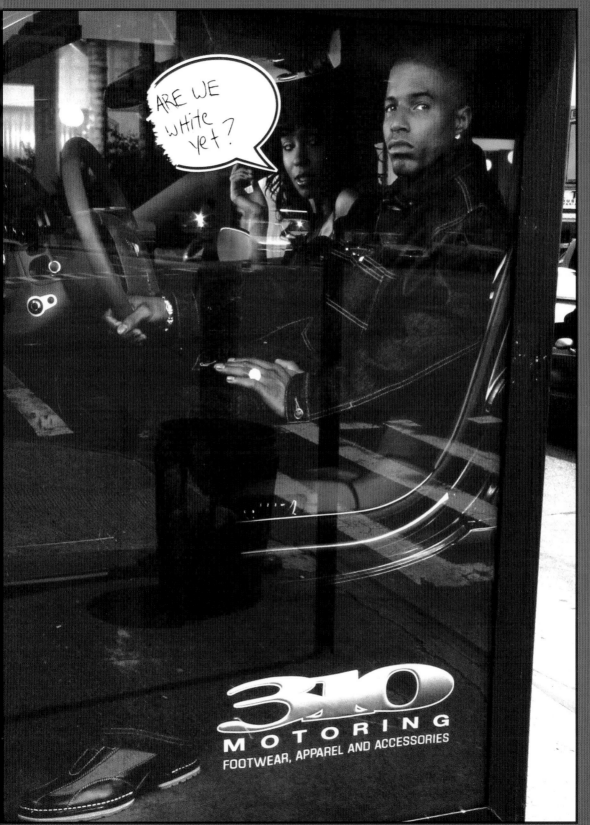

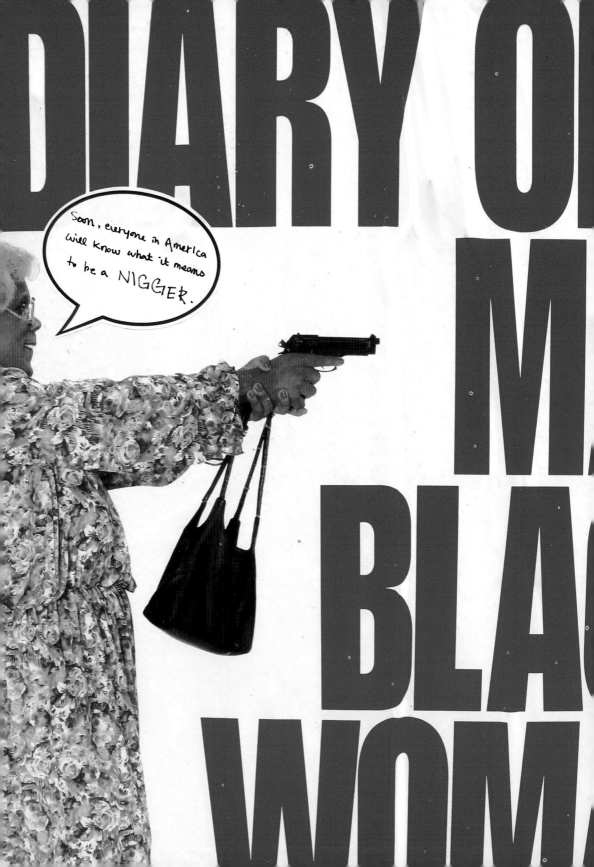

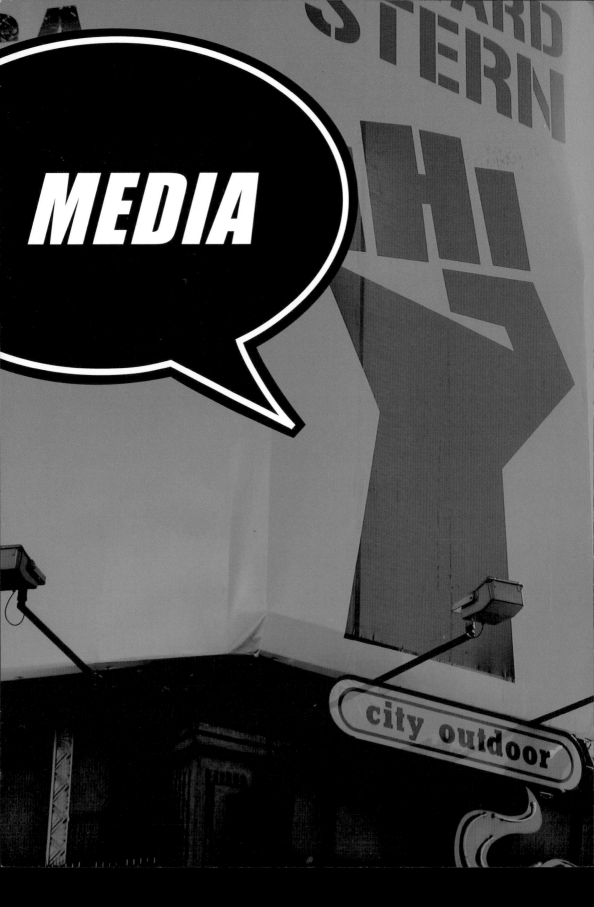

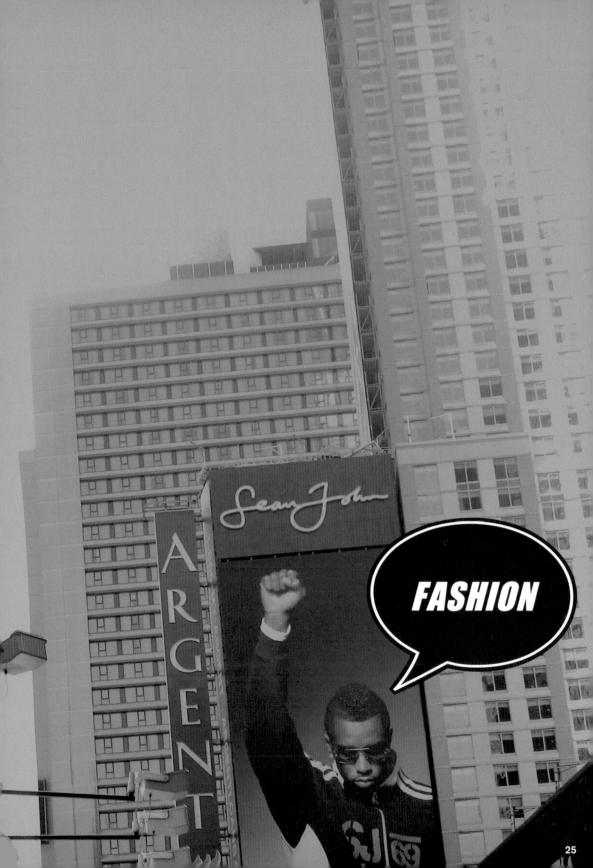

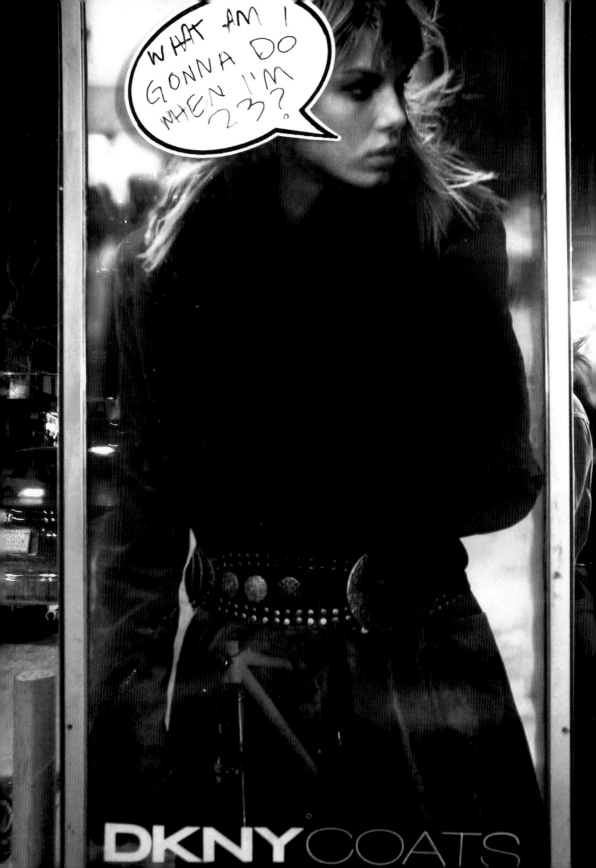

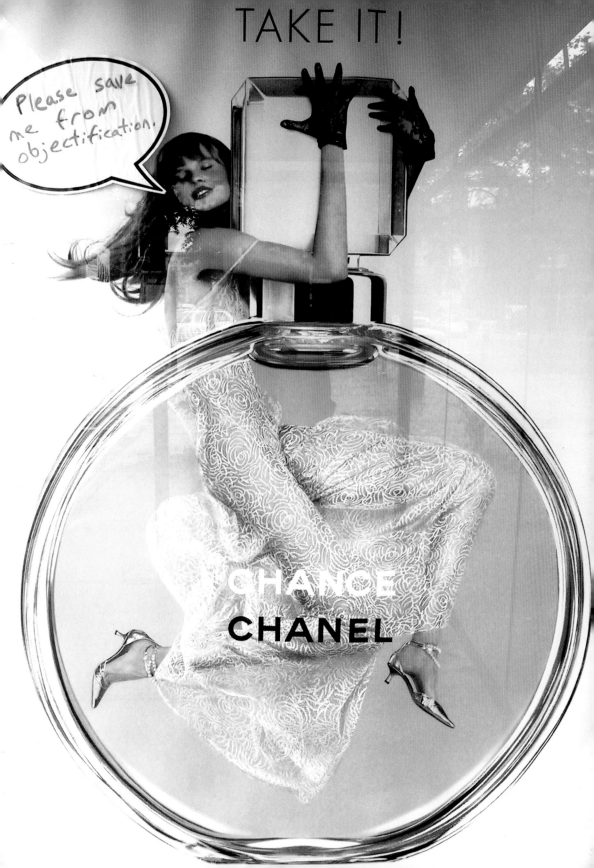

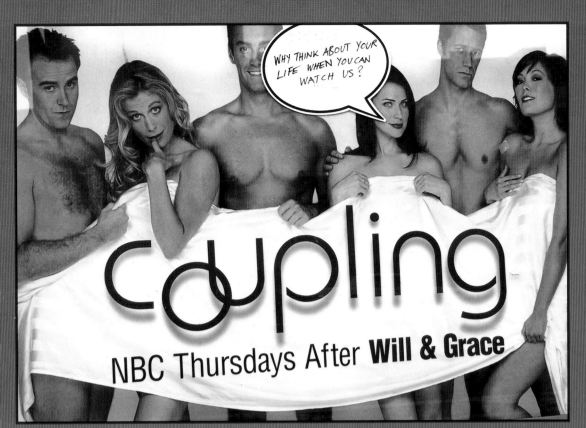

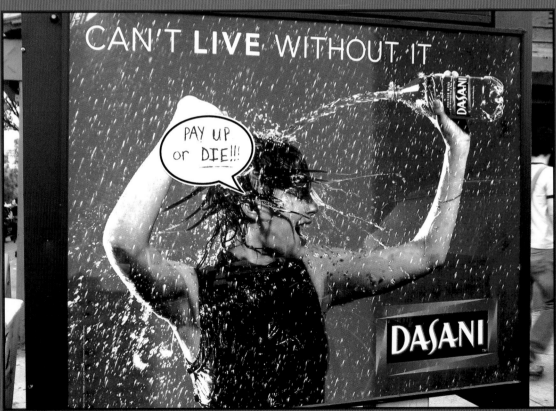

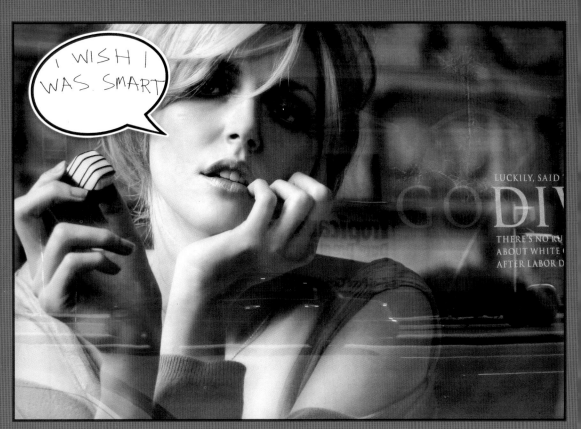

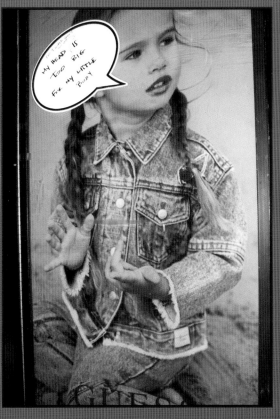

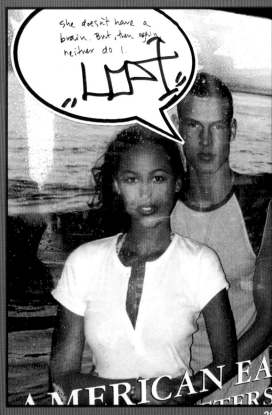

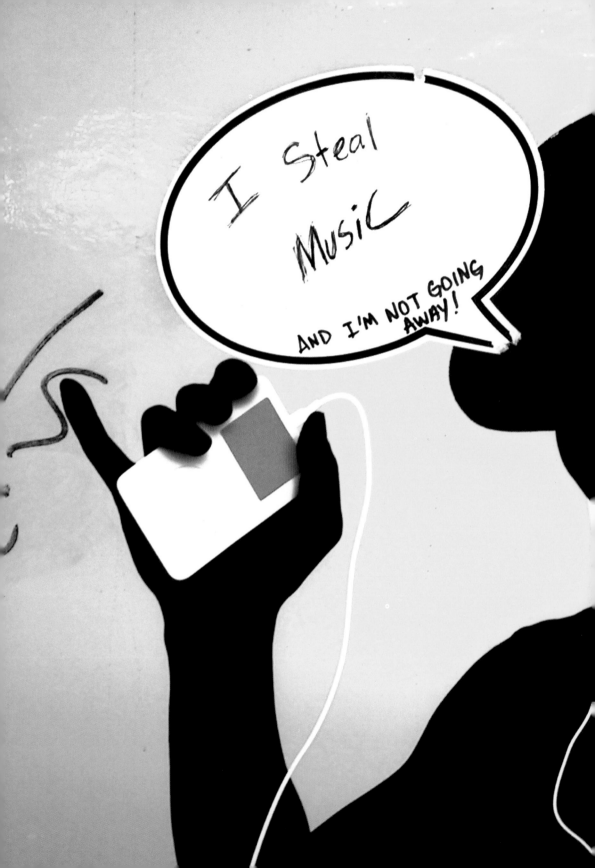

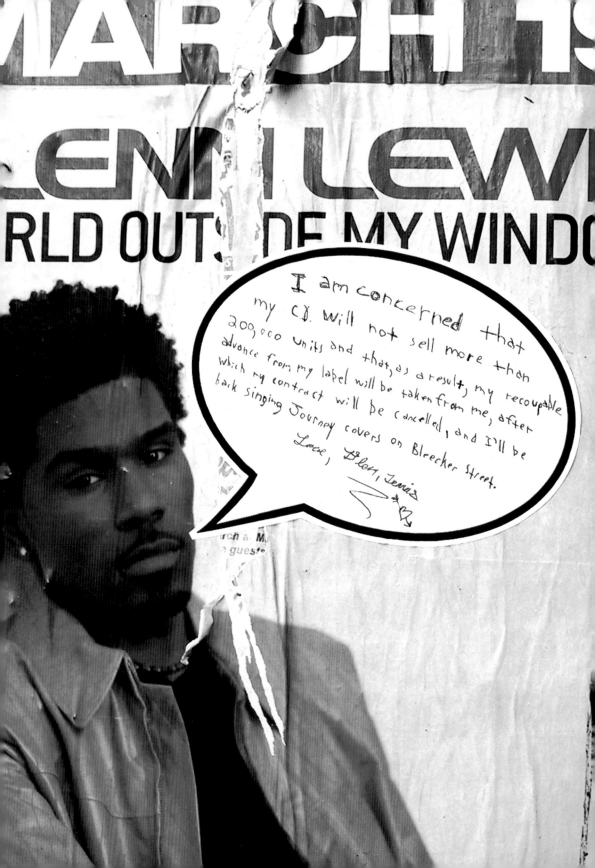

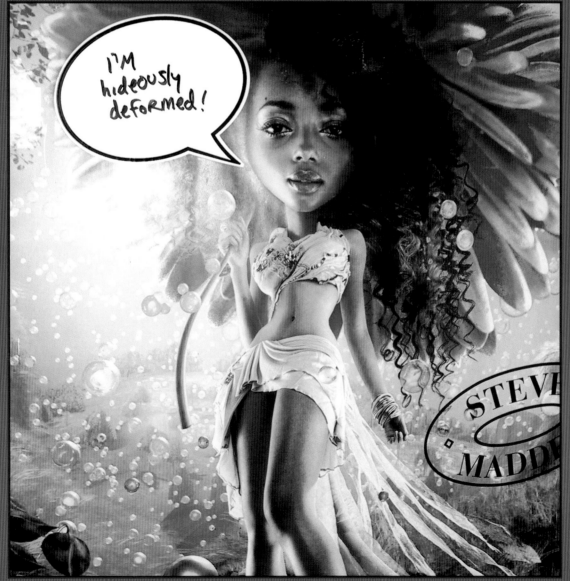

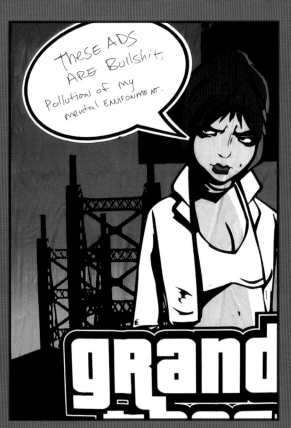

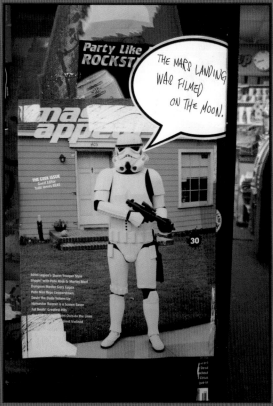

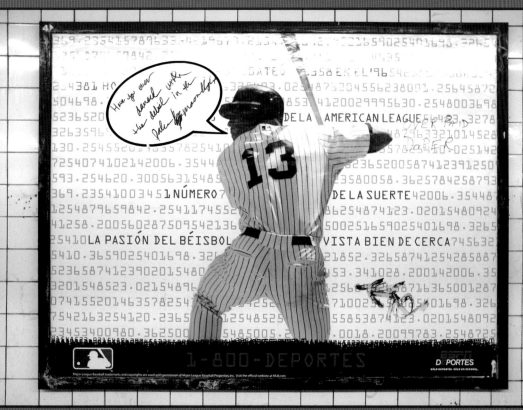

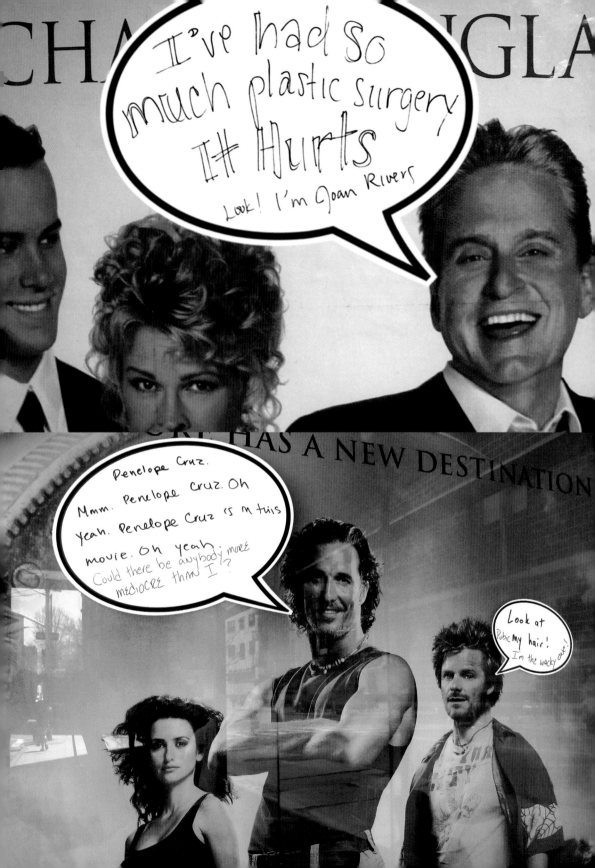

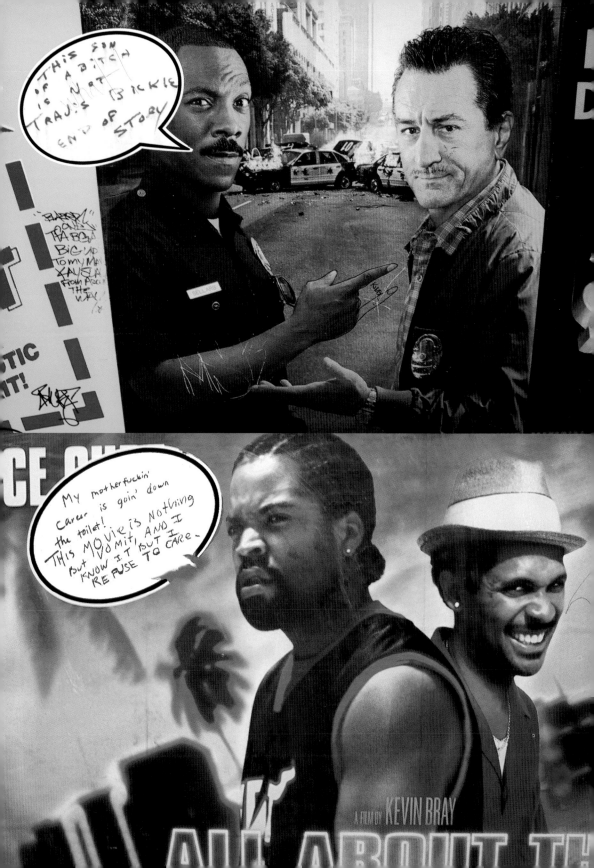

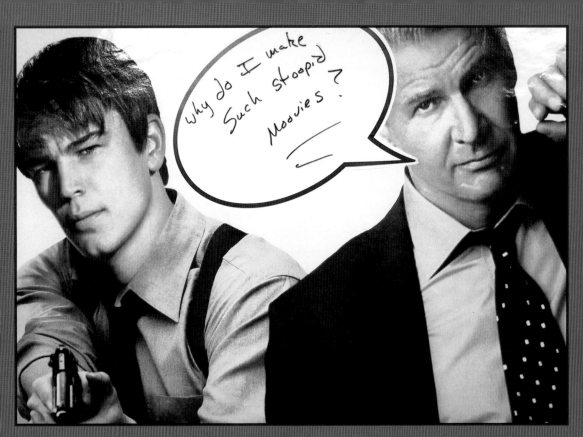

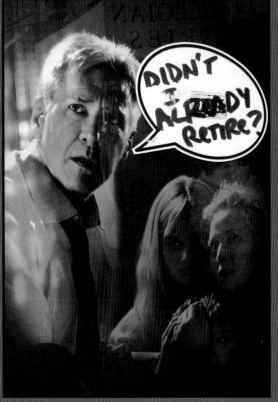

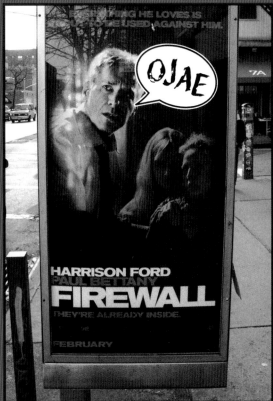

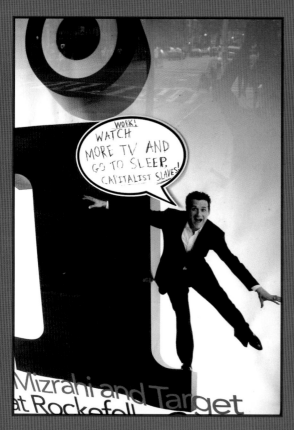

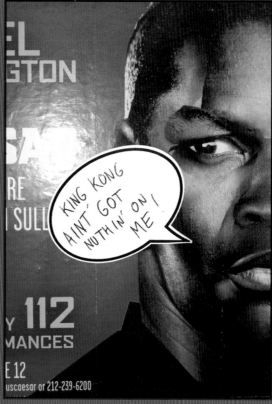

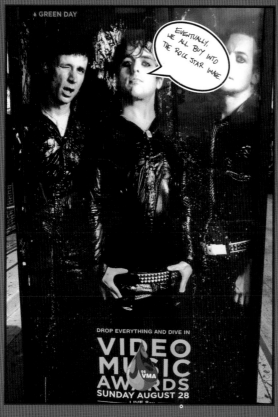

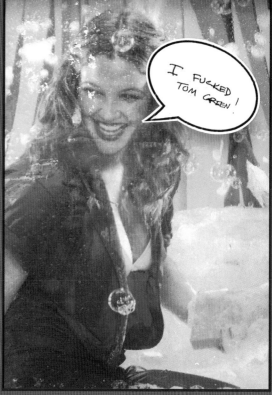

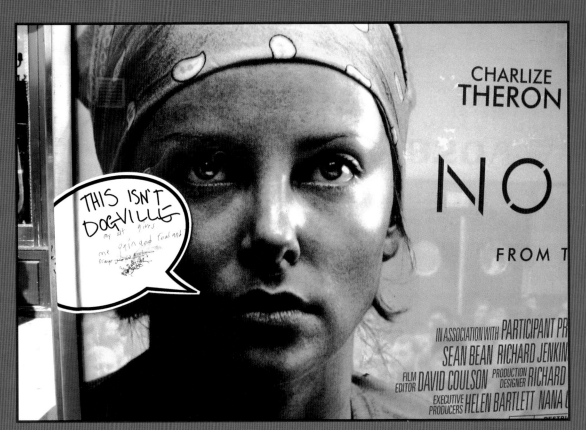

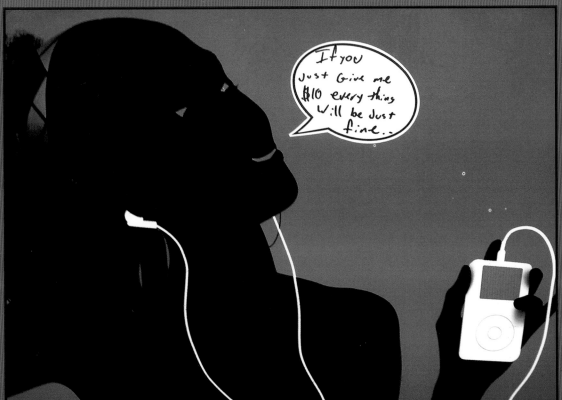

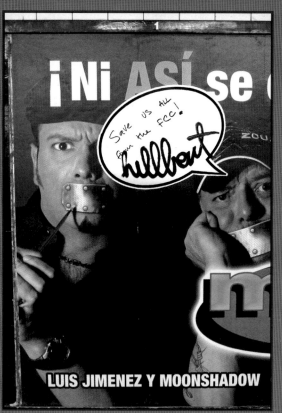

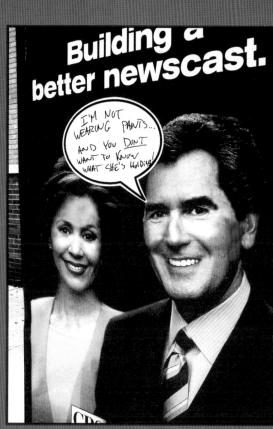

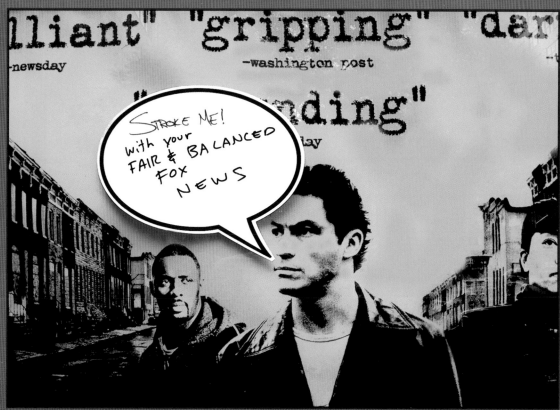

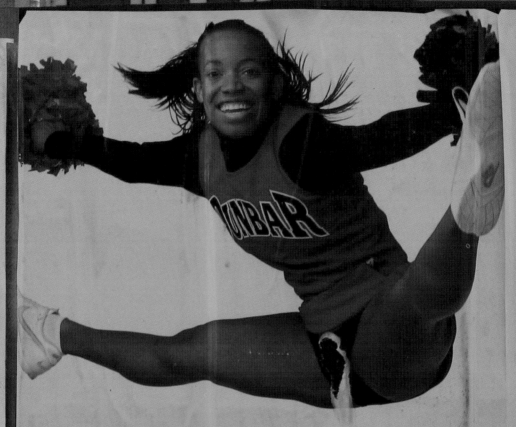

THE
SENIOR.

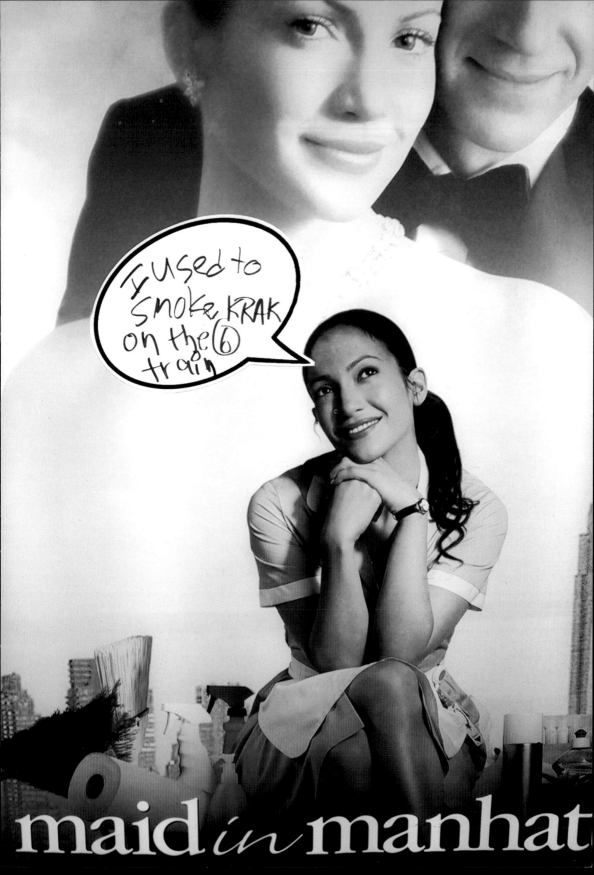

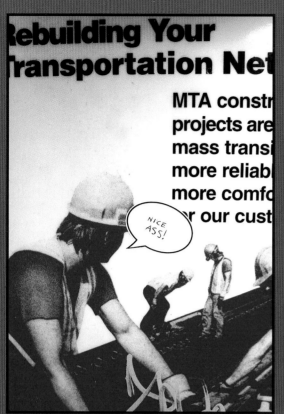

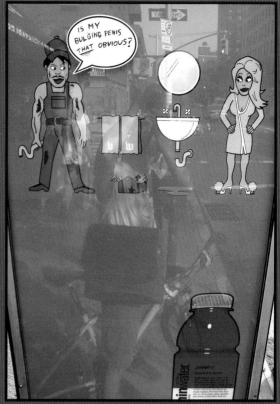

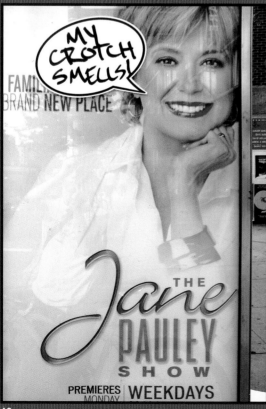

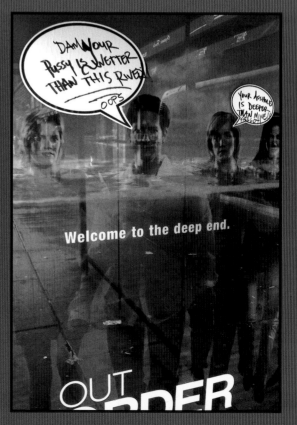

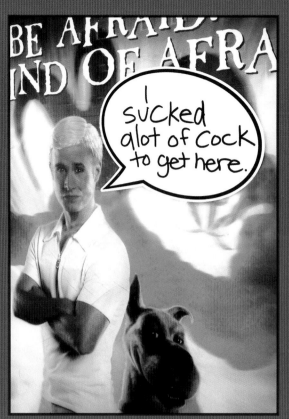

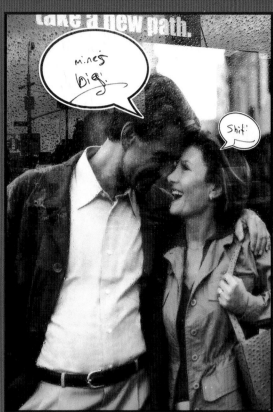

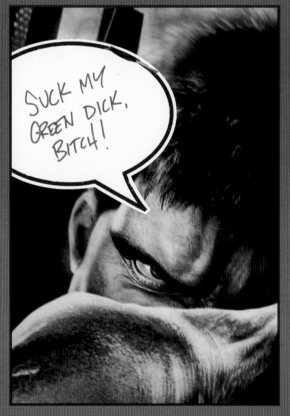

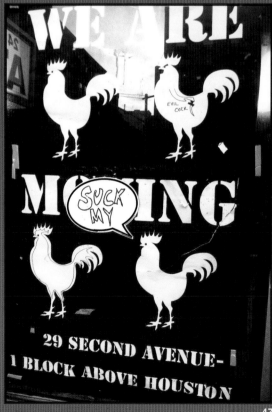

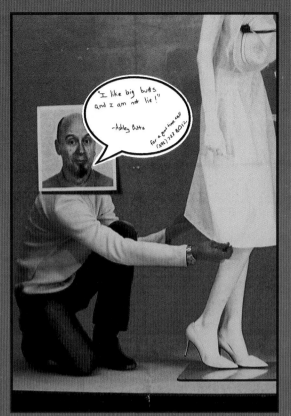

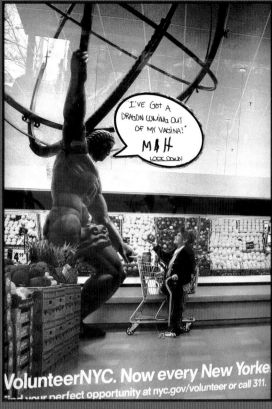

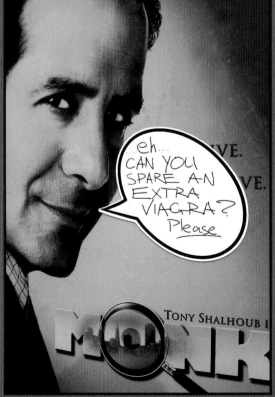

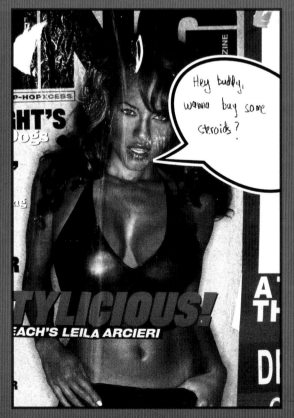

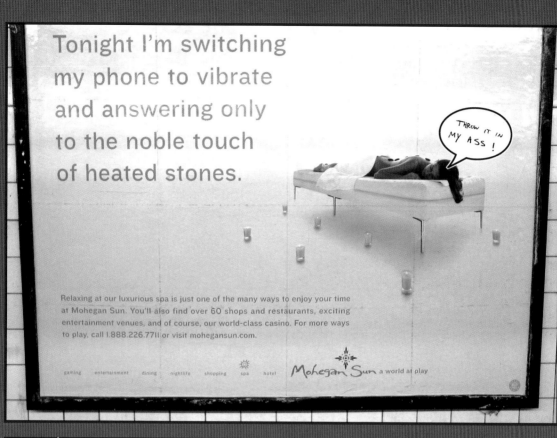

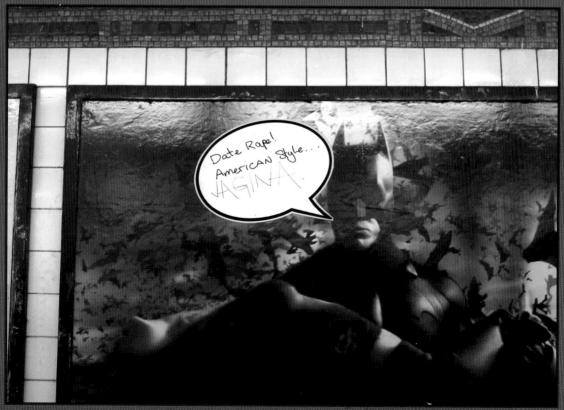

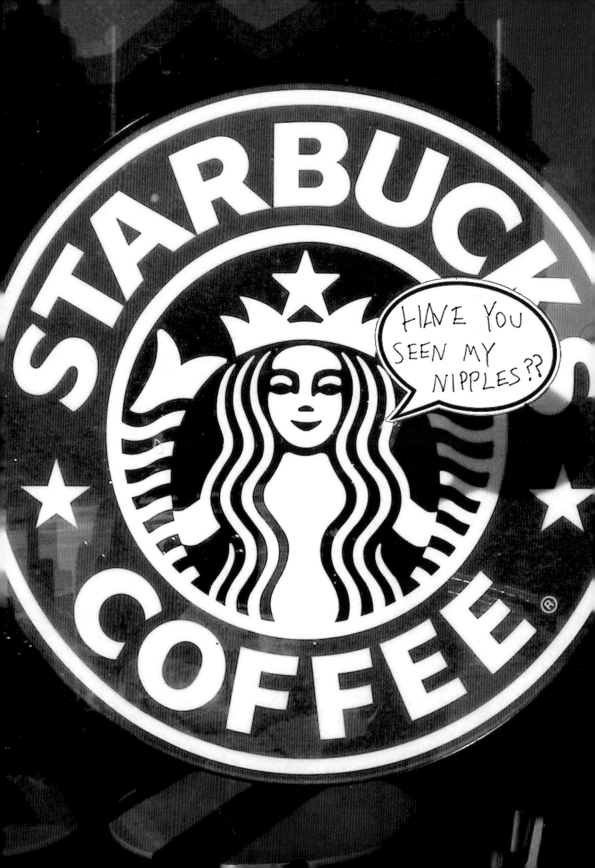

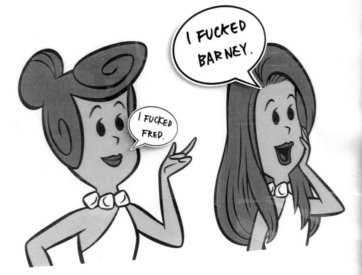

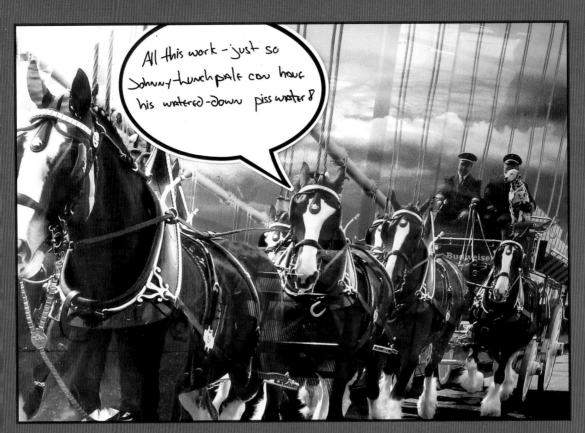

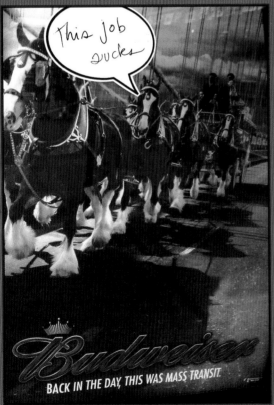

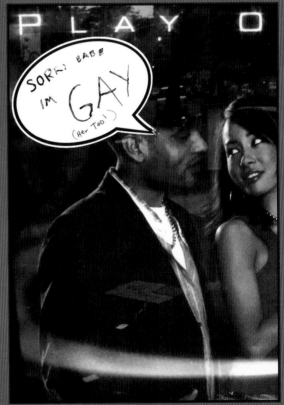

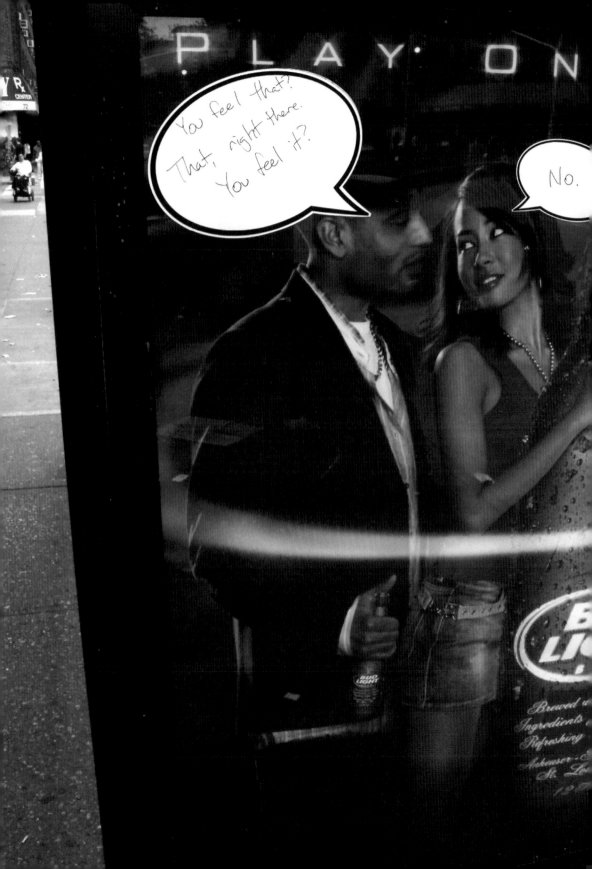

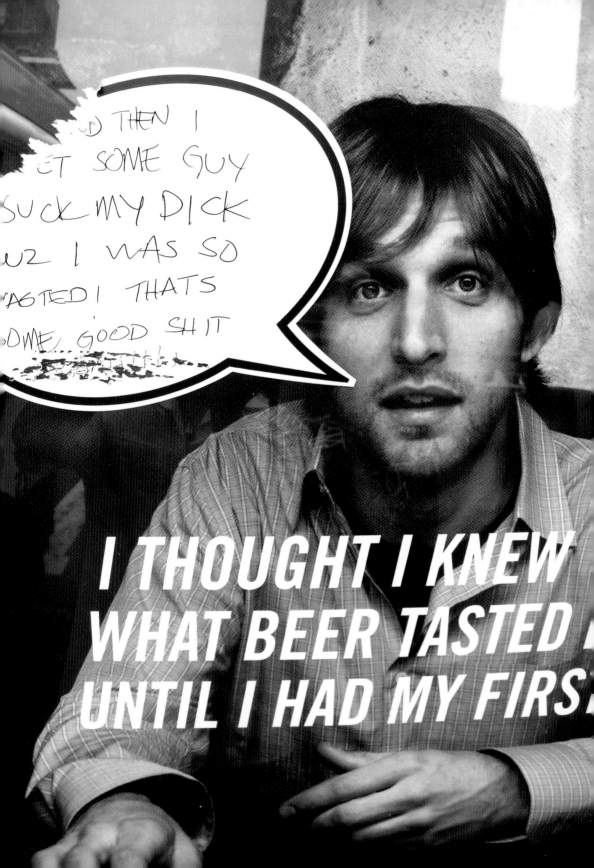

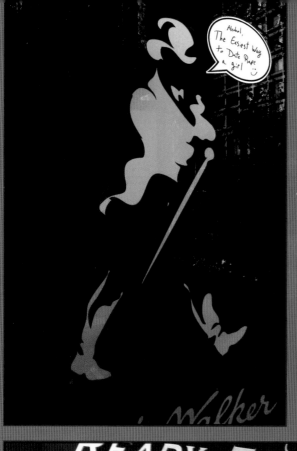

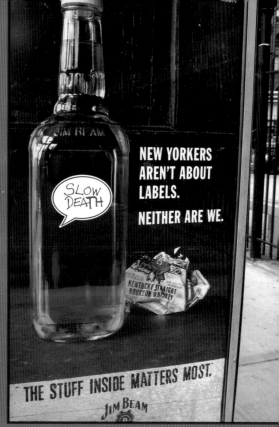

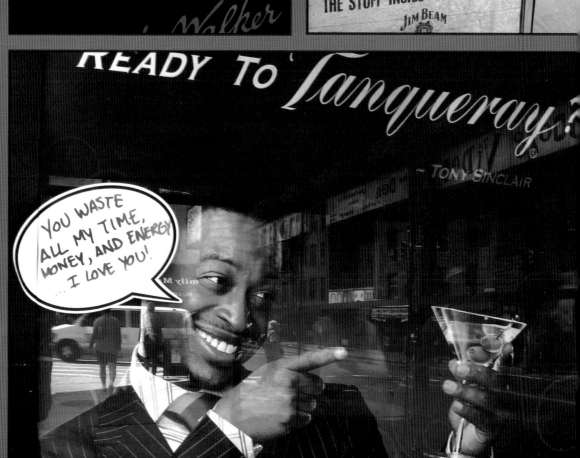

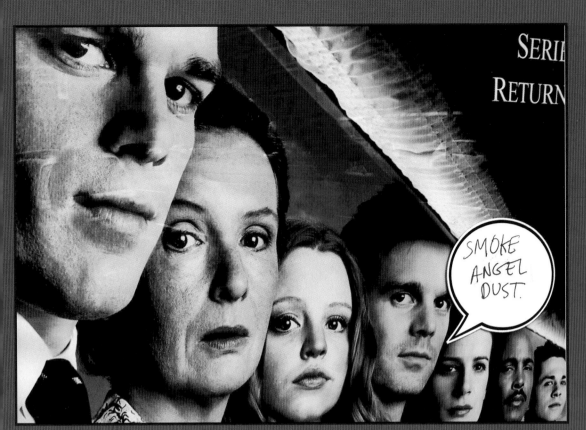

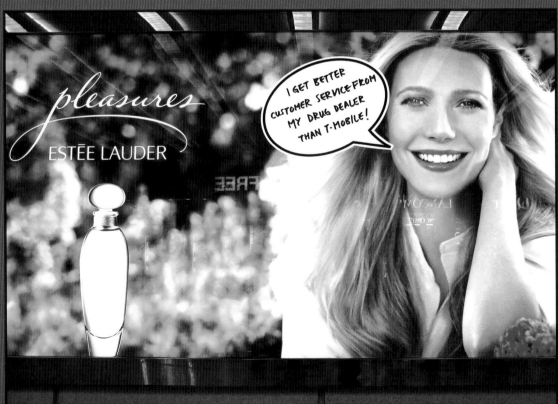

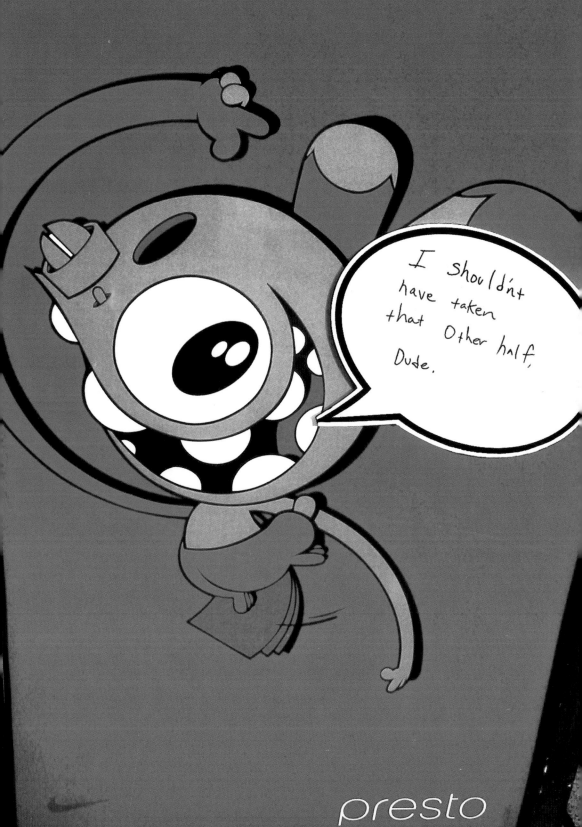

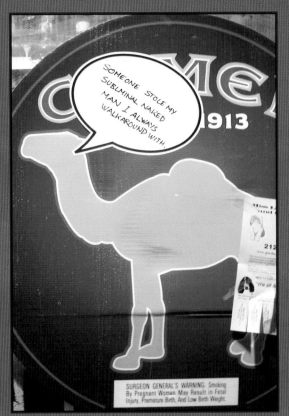

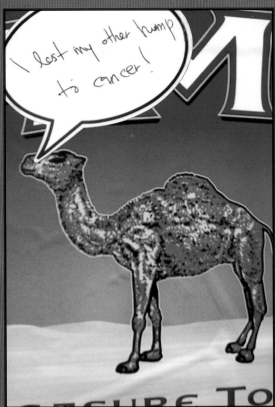

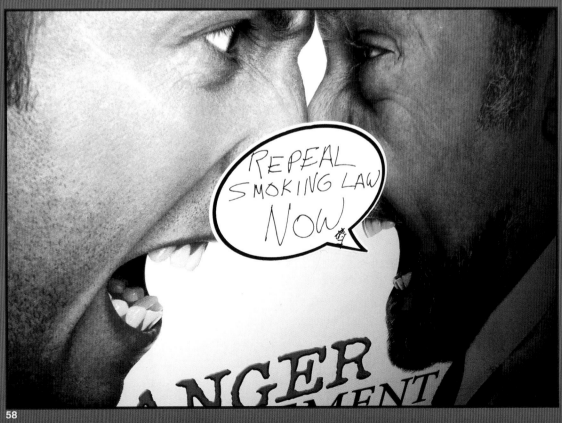

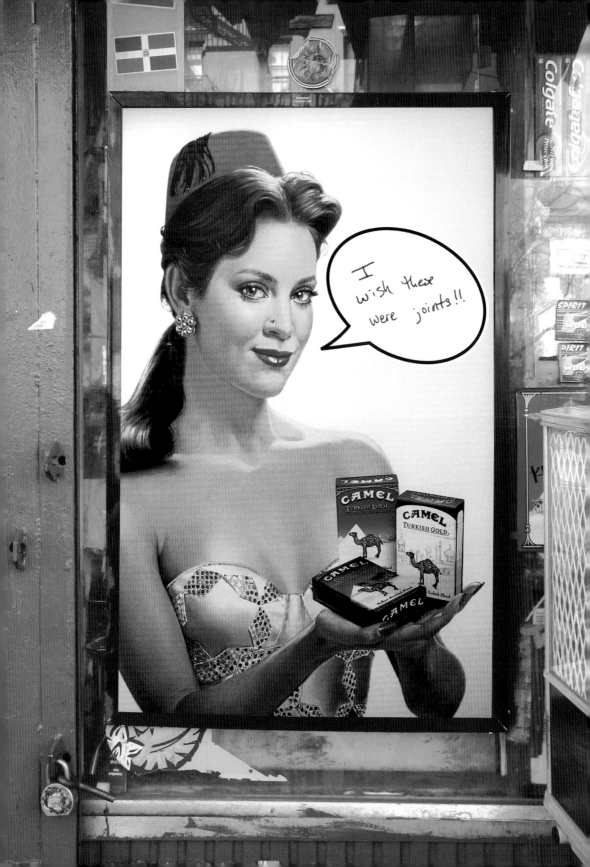

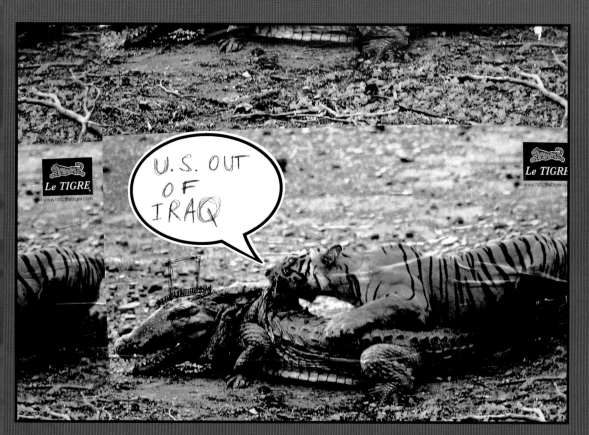

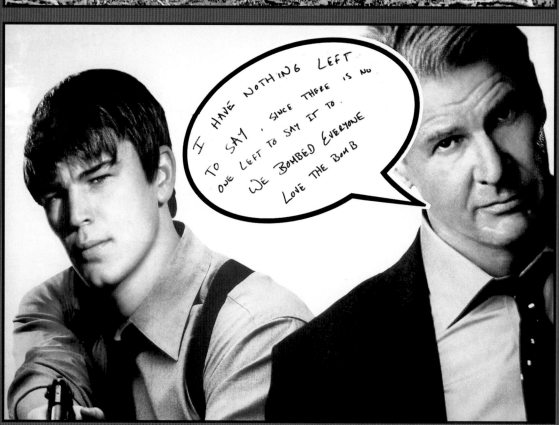

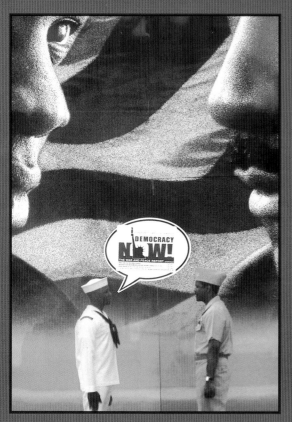

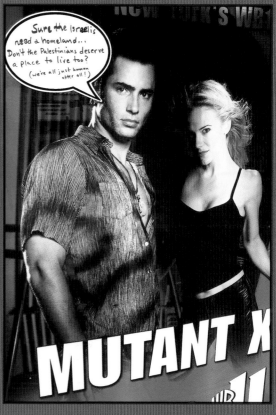

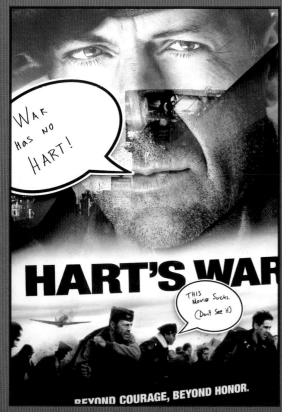

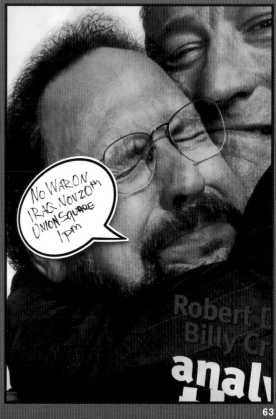

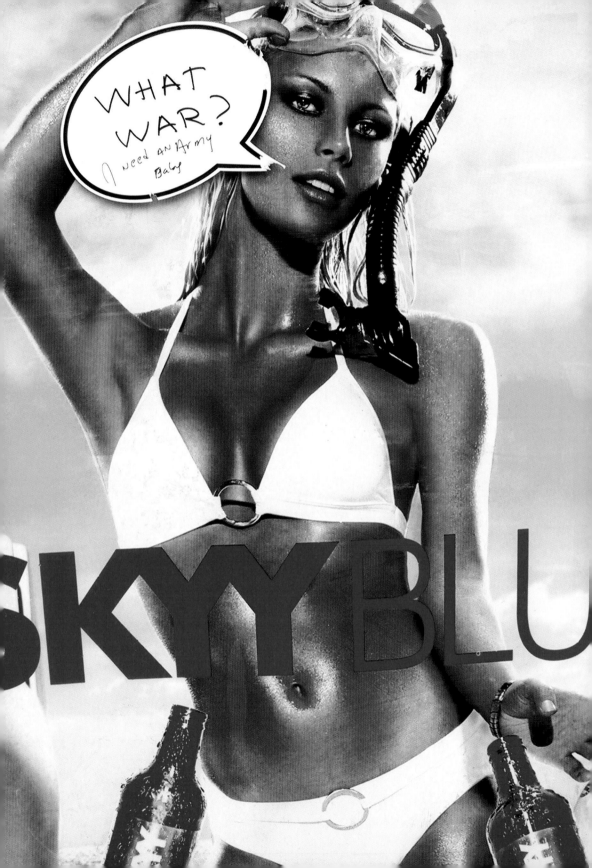

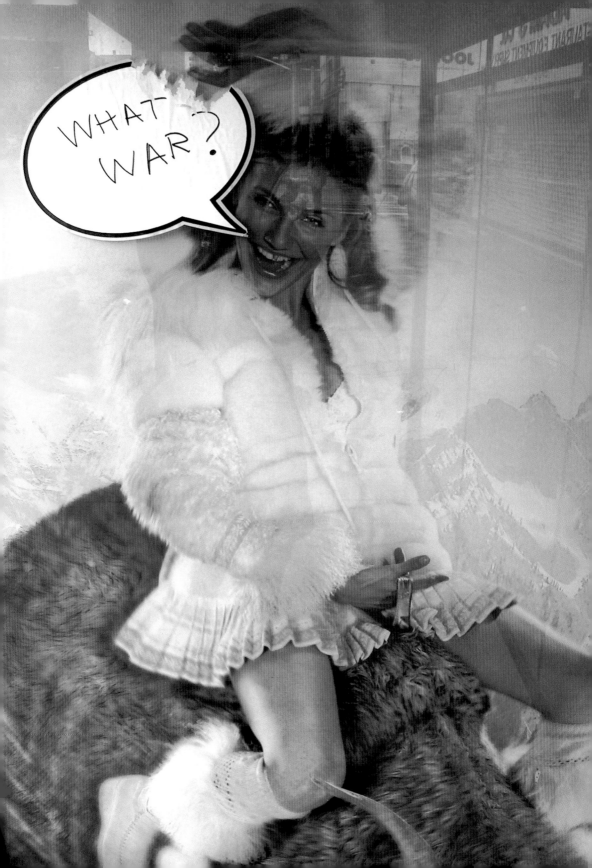

The Evolution of Dumb

DUMBAND

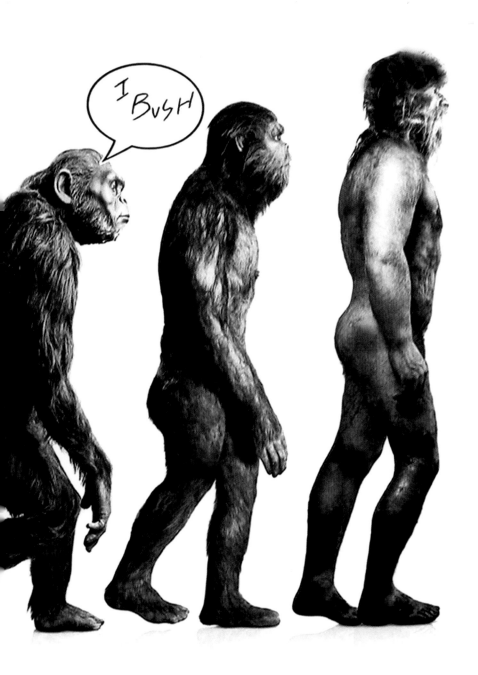

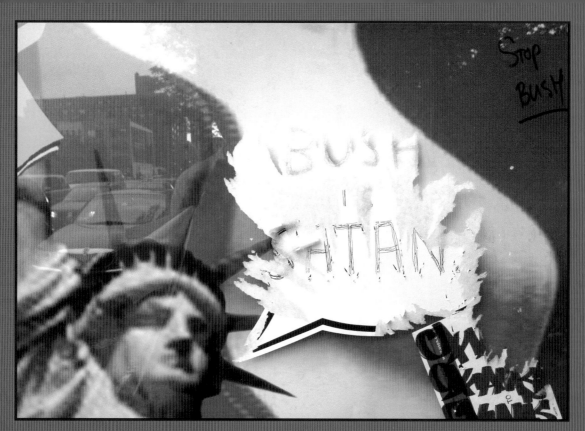

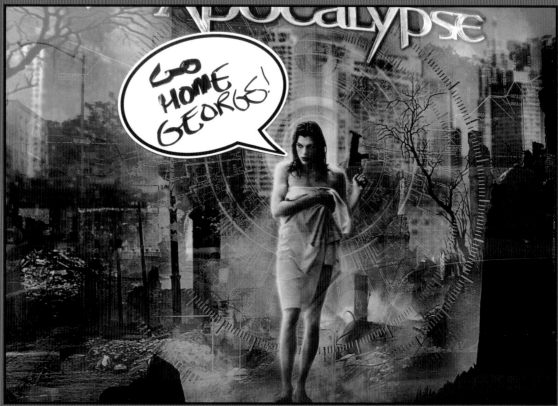

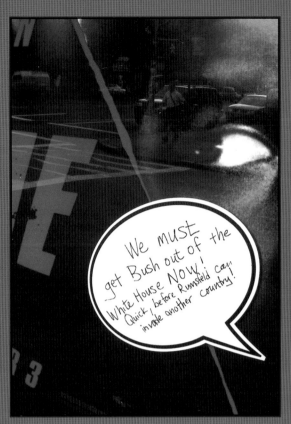

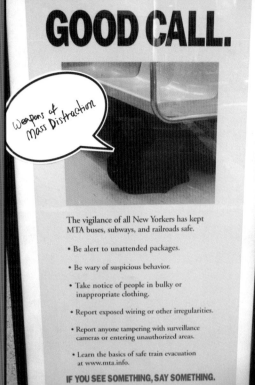

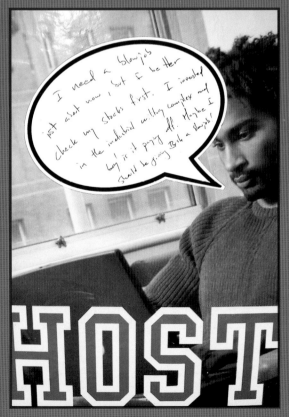

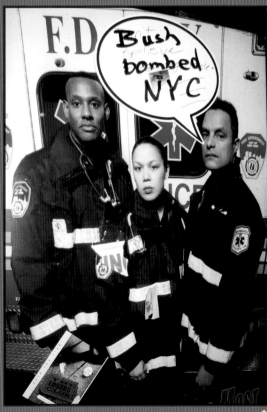

Y.C.

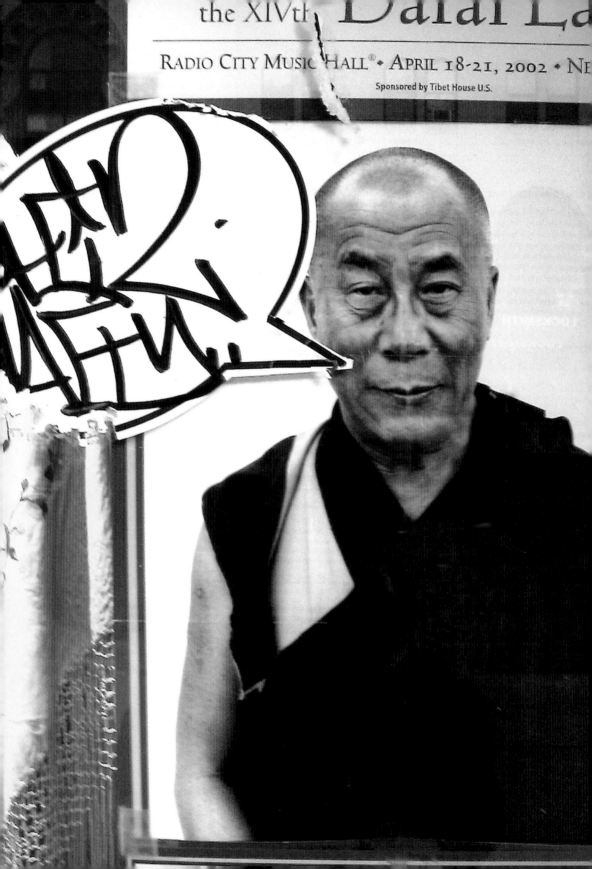

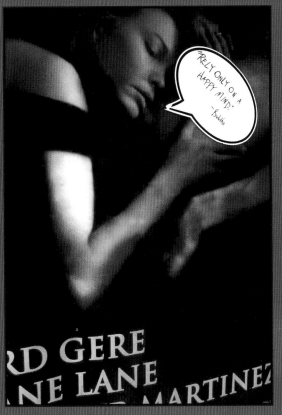

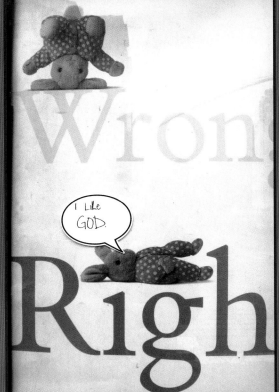

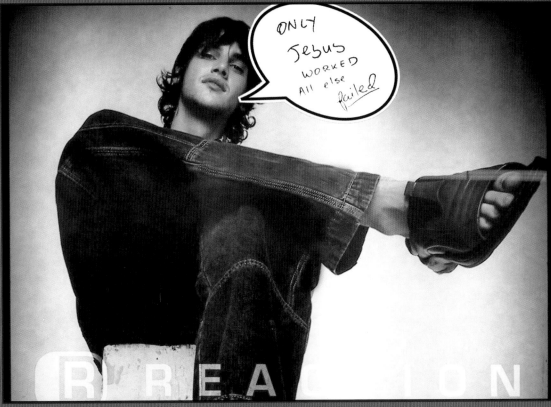

Earth Day in Grand Central

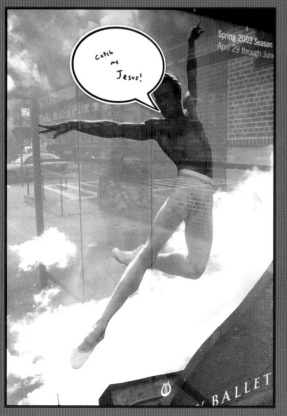

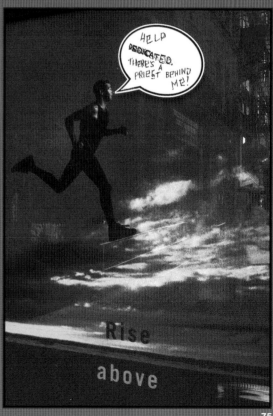

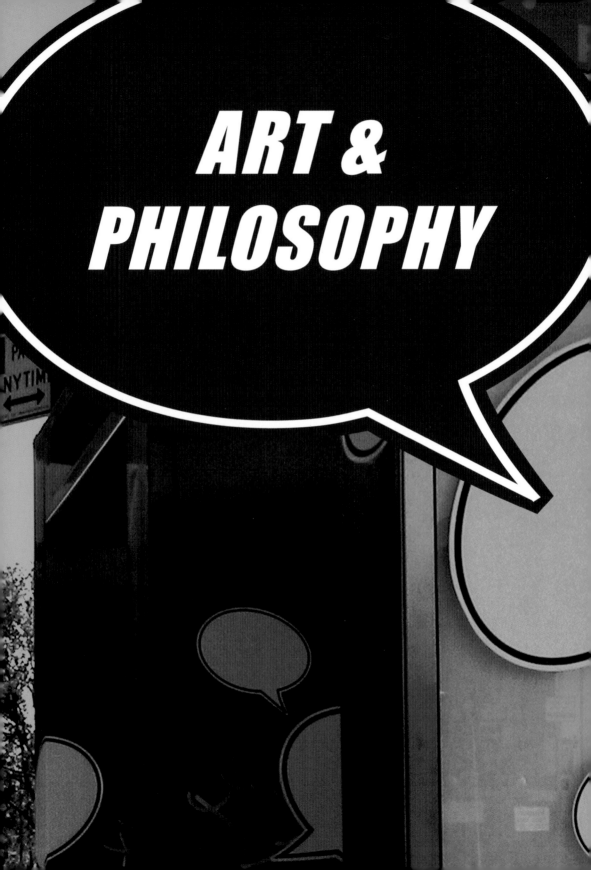

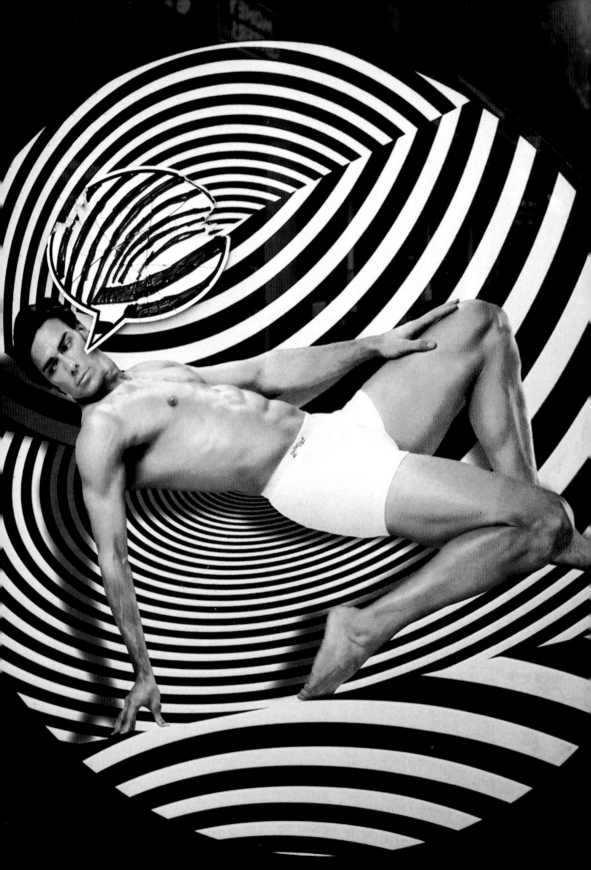

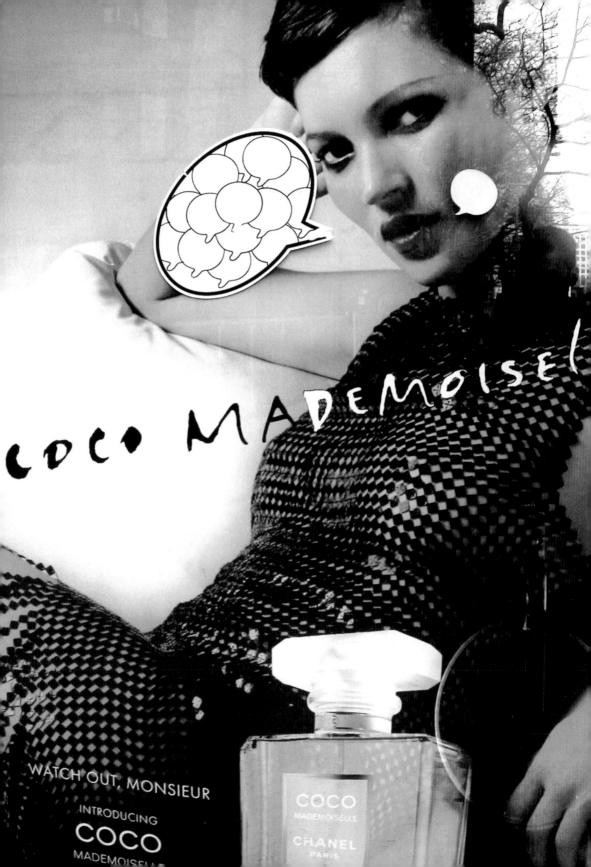

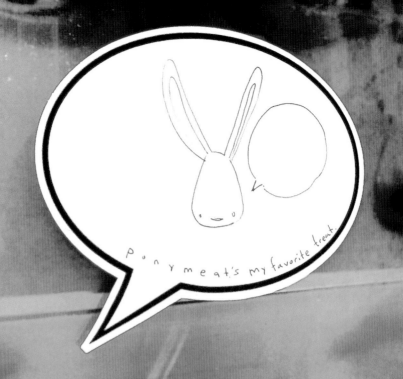

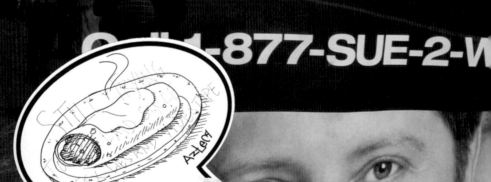

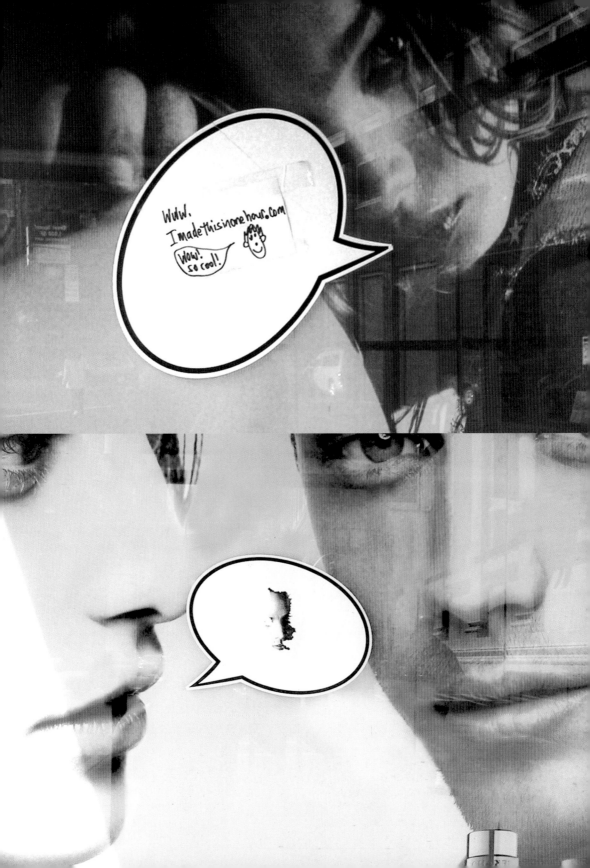

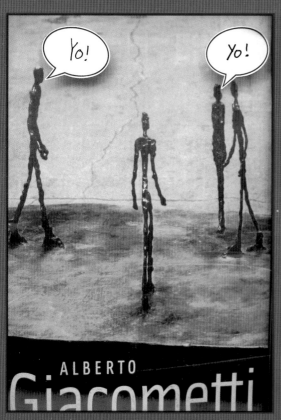

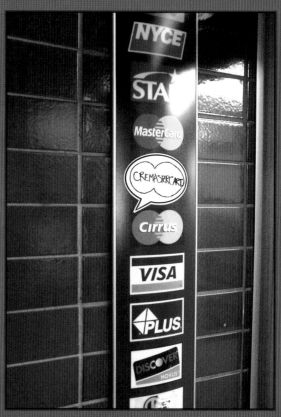

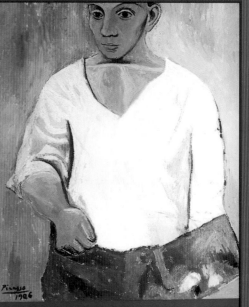

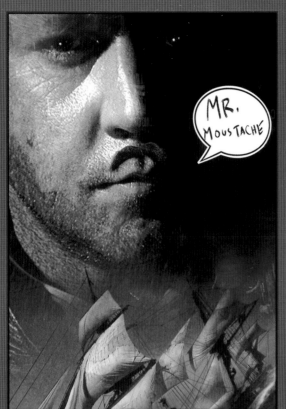

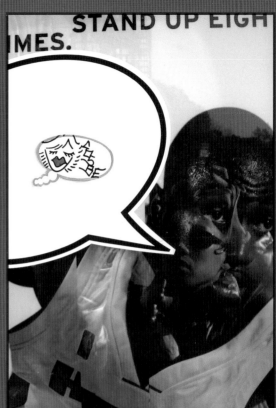

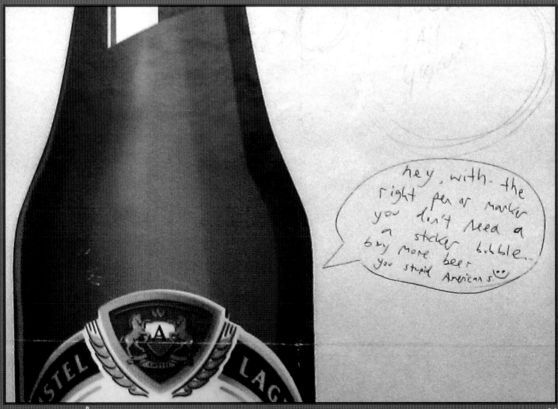

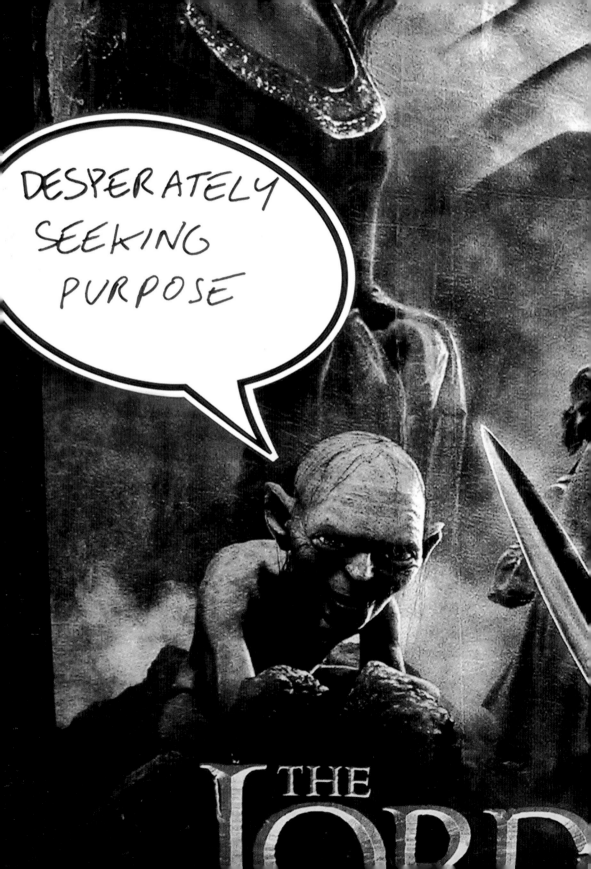

OF RINGS

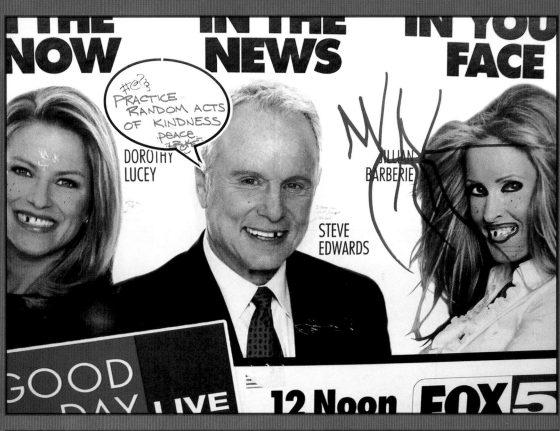

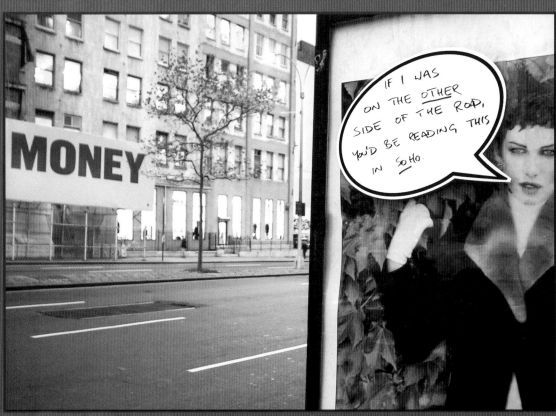

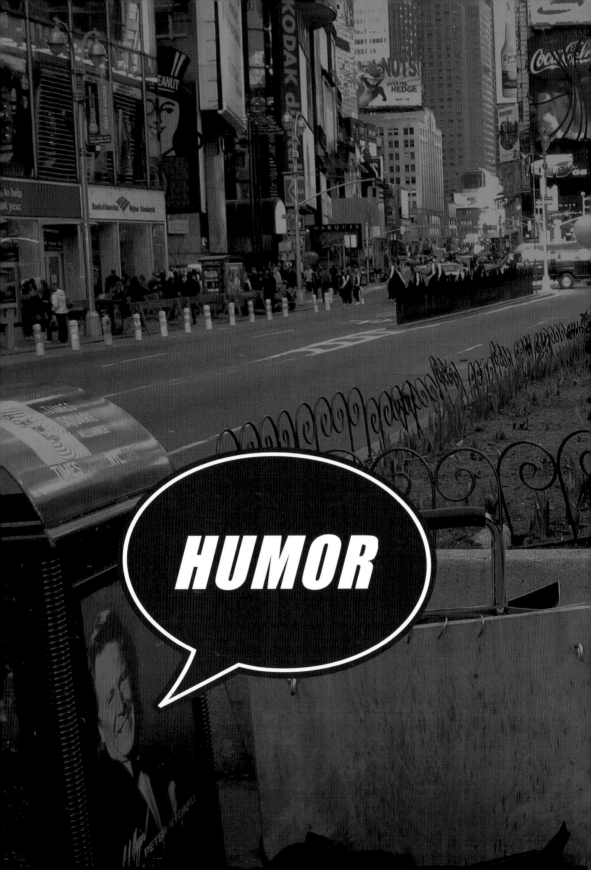

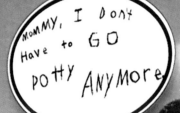
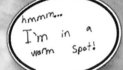

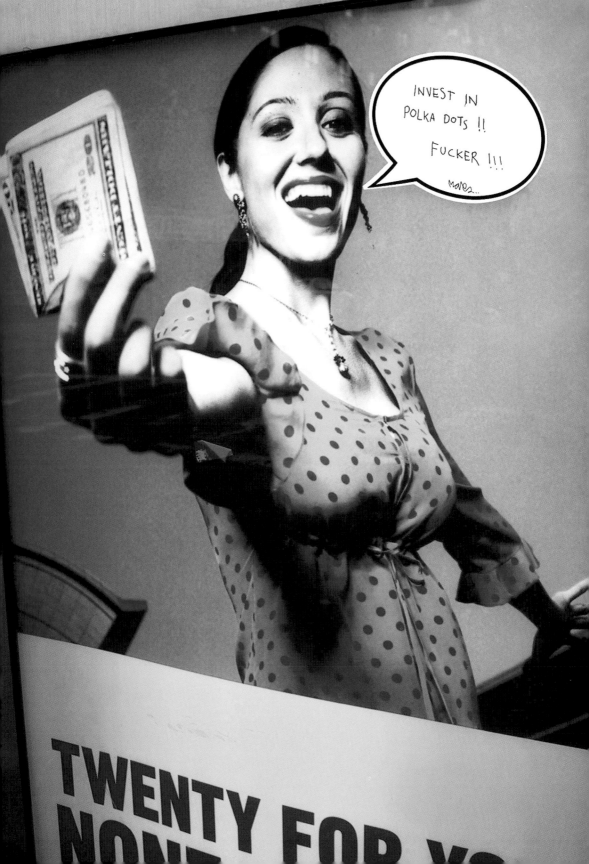

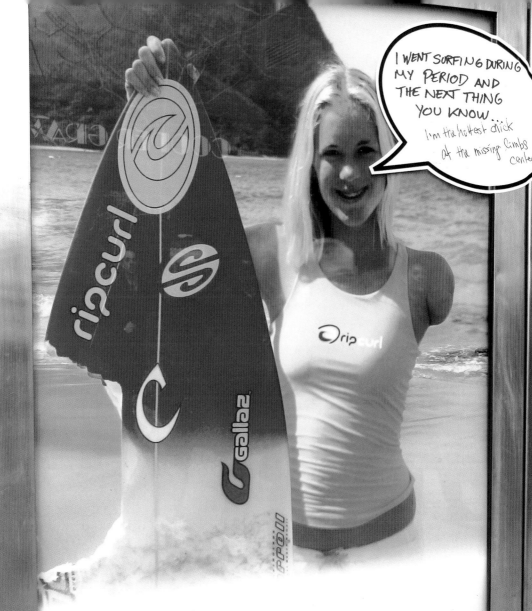

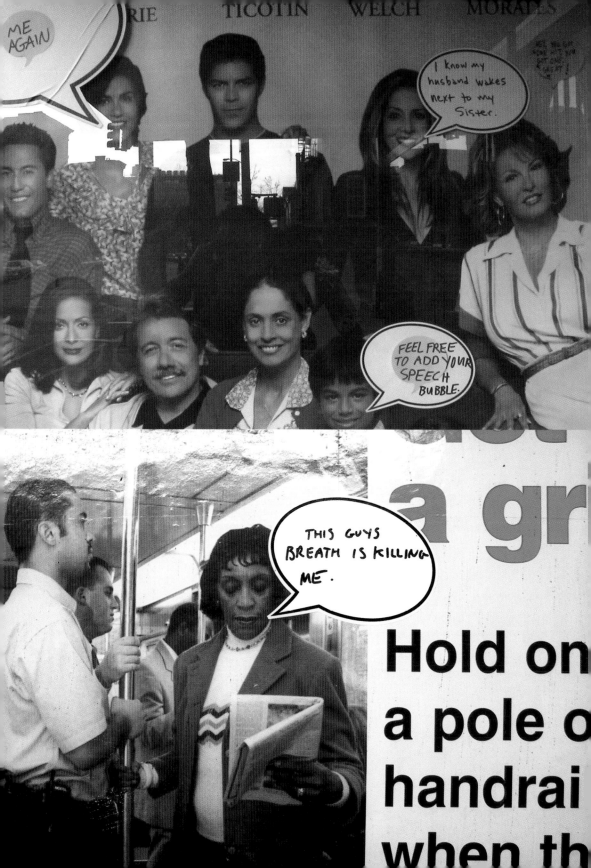

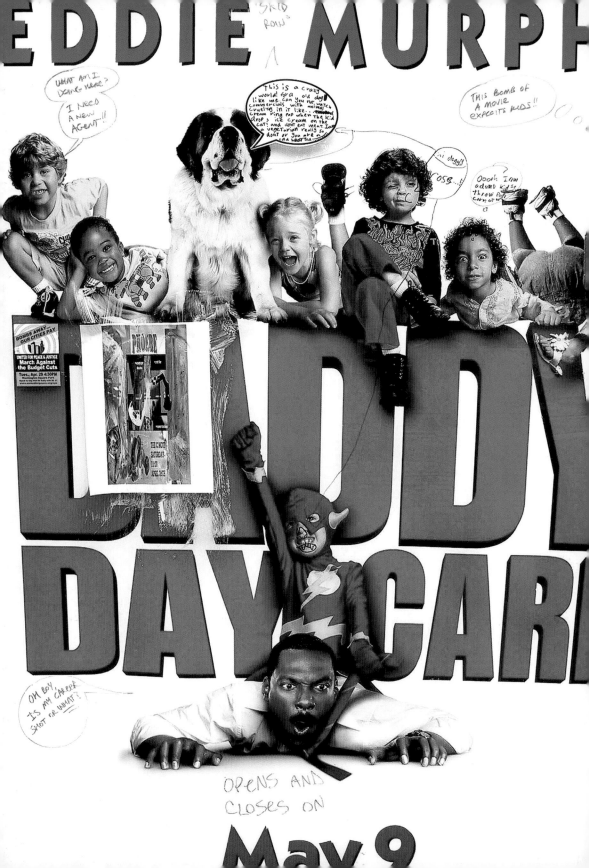

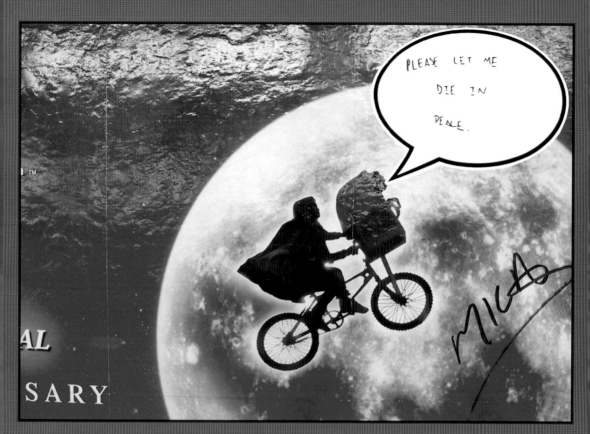

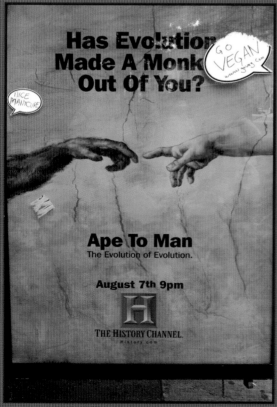

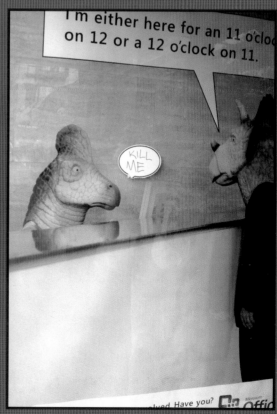

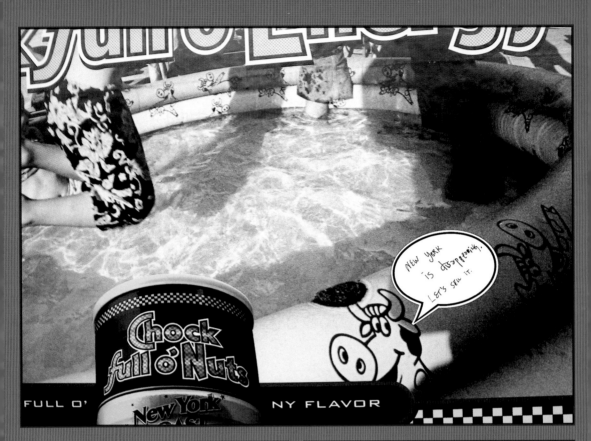

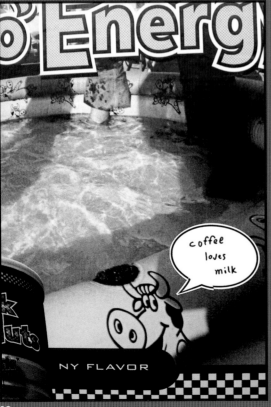

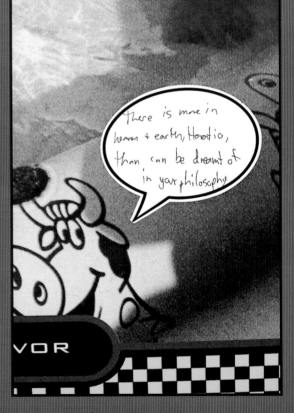

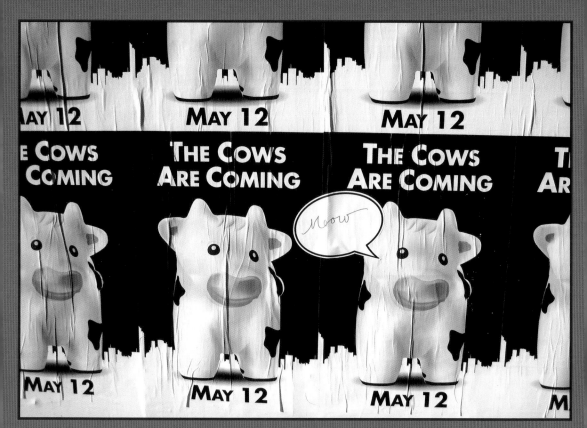

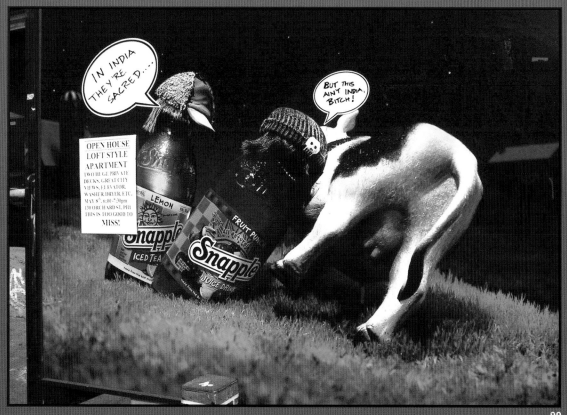

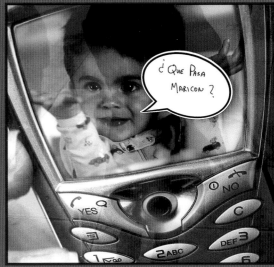

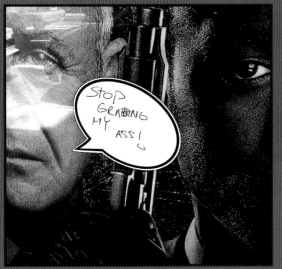

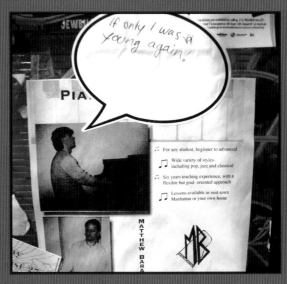

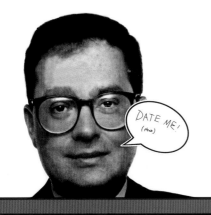

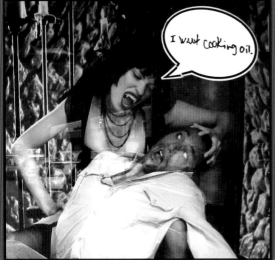

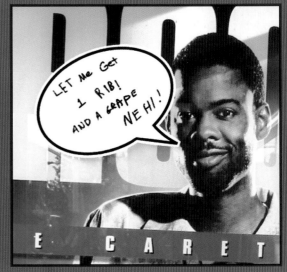

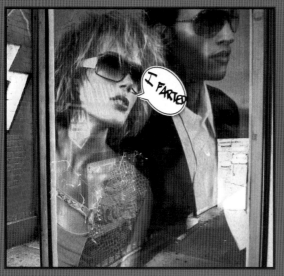

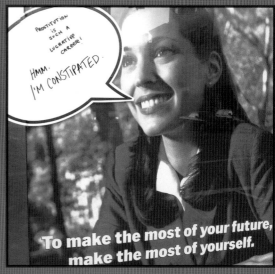

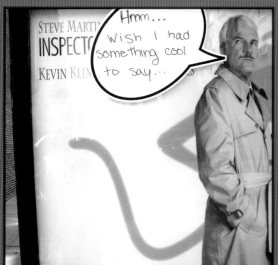

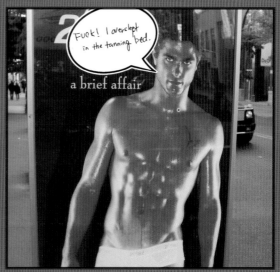

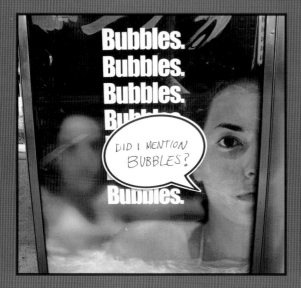

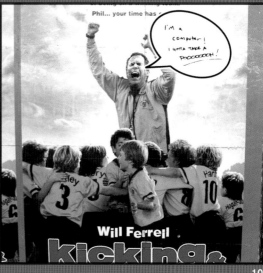

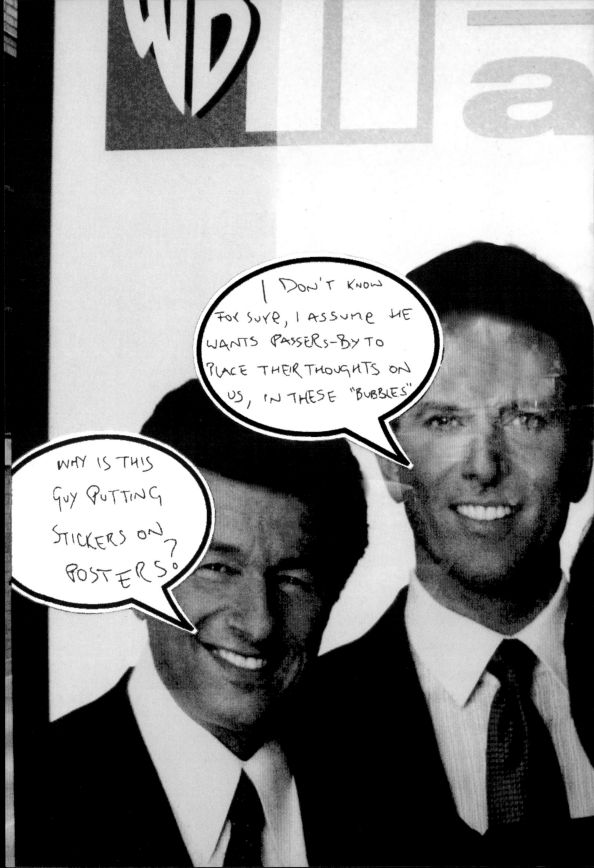

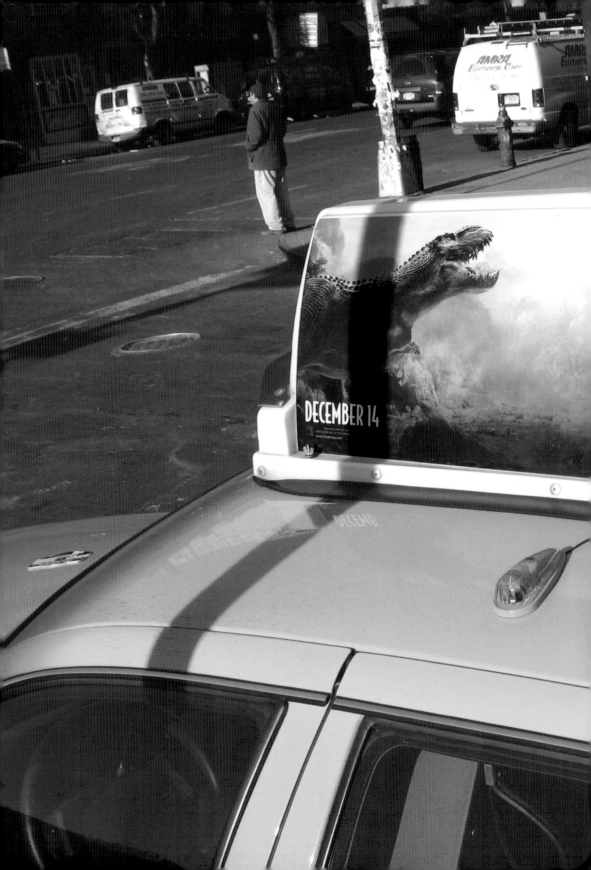

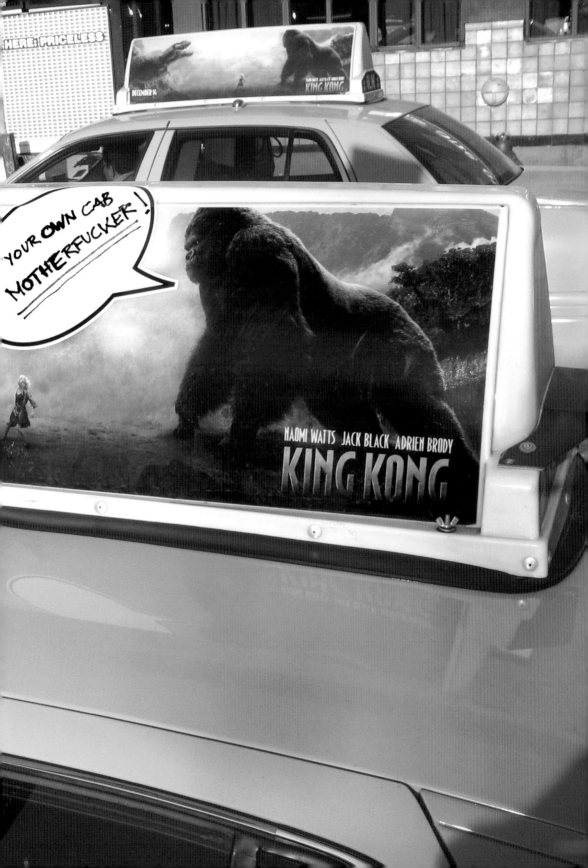

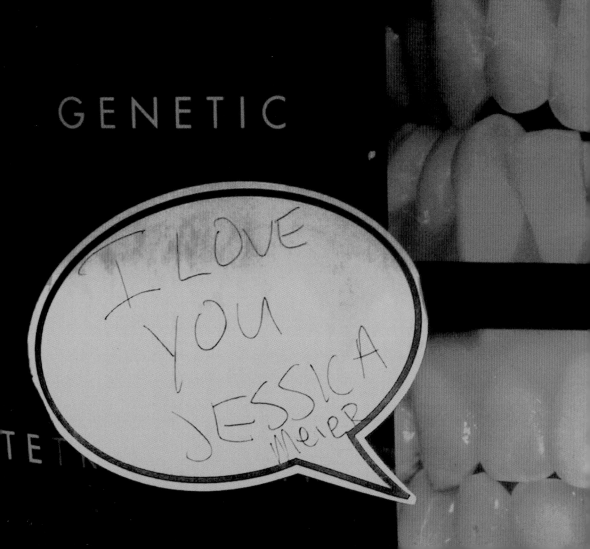

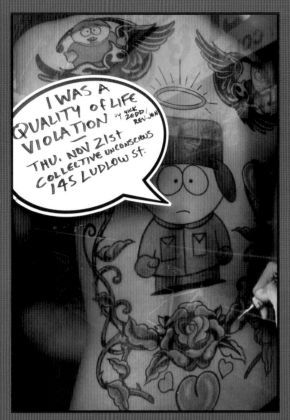

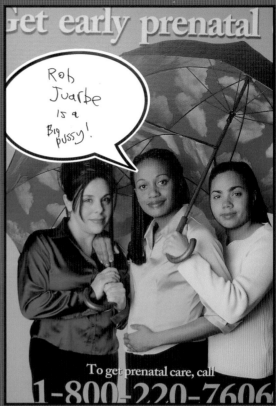

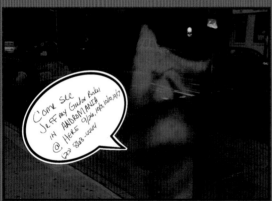

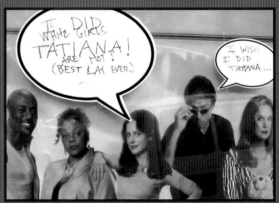

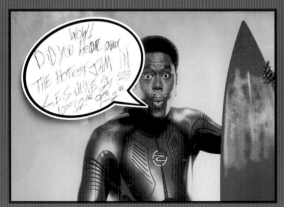

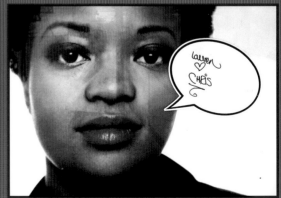

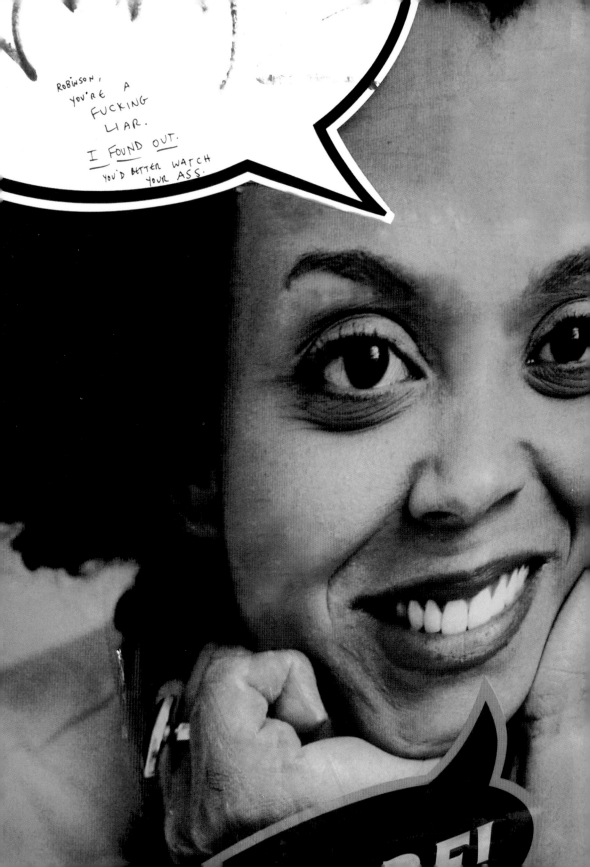

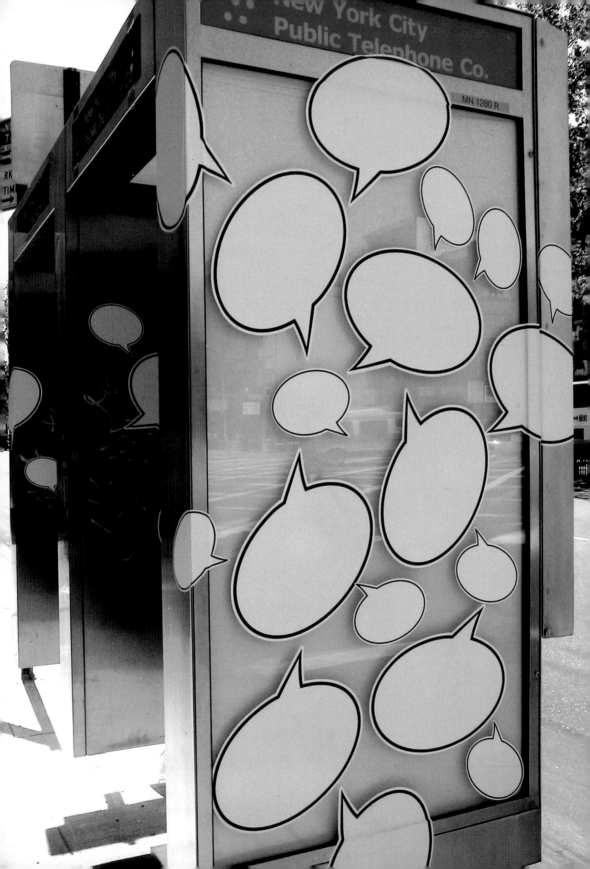

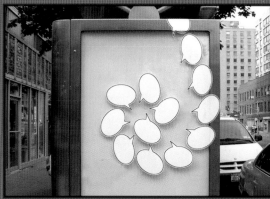

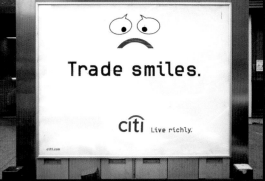

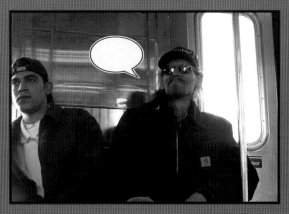

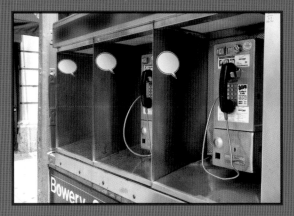

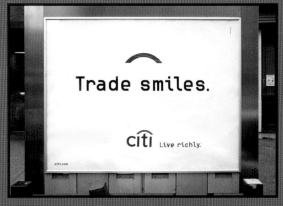

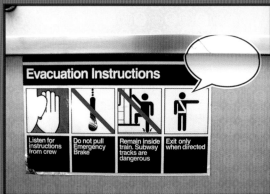

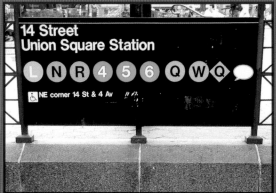

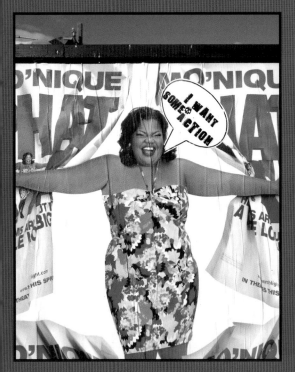

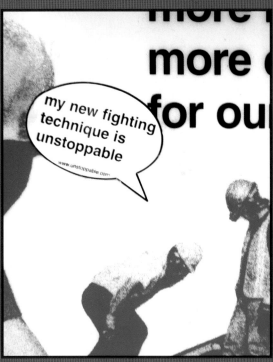

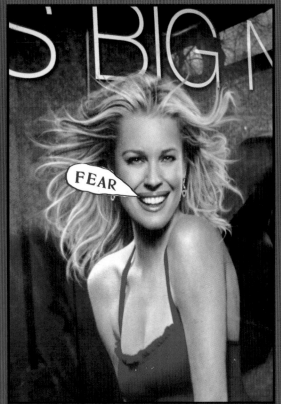

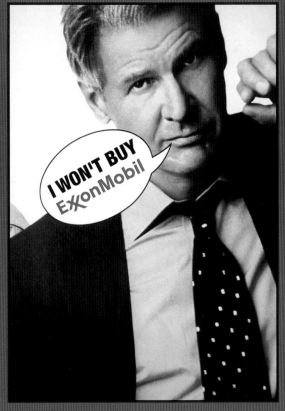

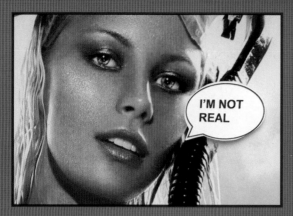

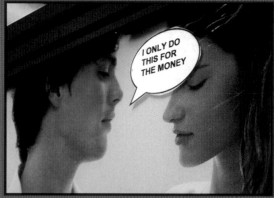

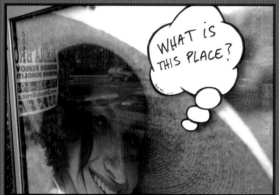

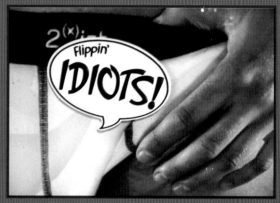

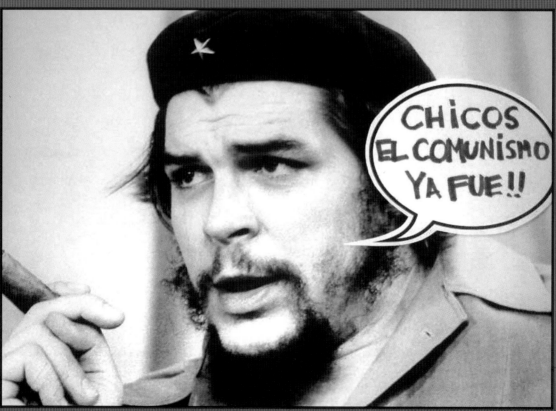

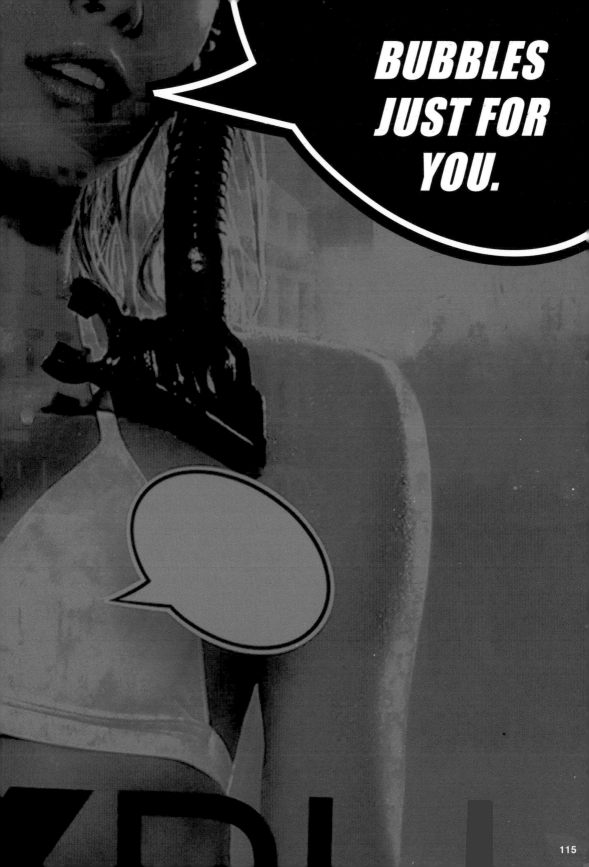

Prince St

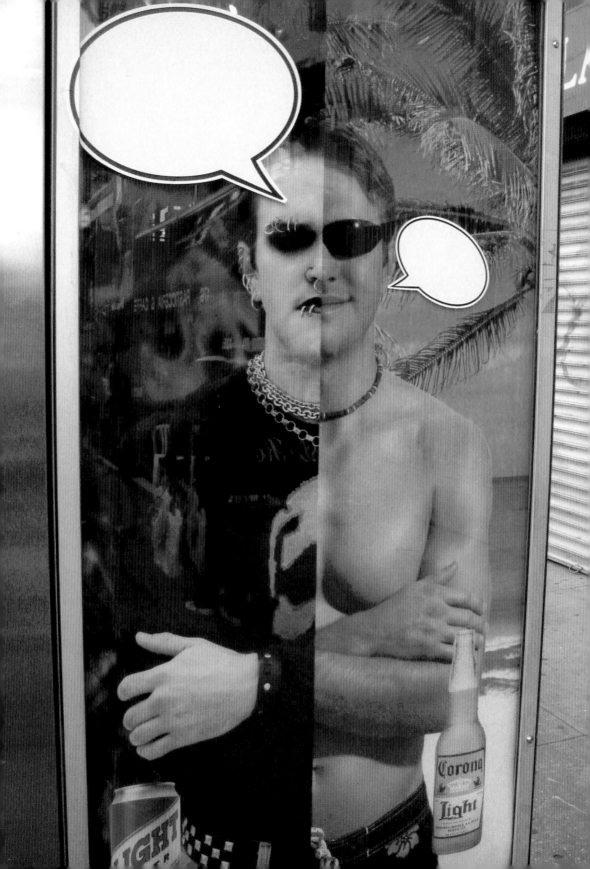

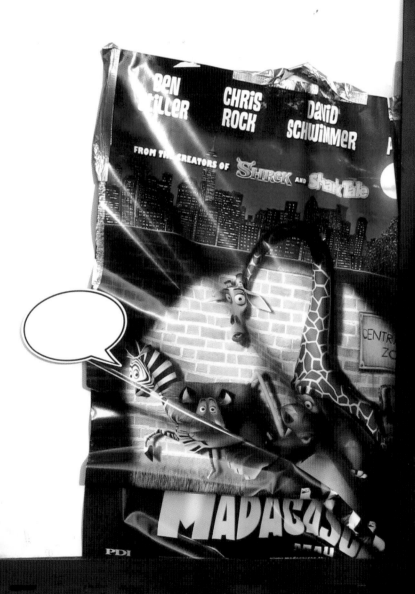

KING

DECEMBER 14

ELDES

...Times
Bestselling
Author
Christopher
Paolini

THE EPIC CONTI

NOW AVAILABLE IN PAPERBACK—WITH OVER 2.5 MIL
The power comes to life—a major motion picture in s

Log on to www.alagaesia.com
you can meet Christophe

NG

SHO

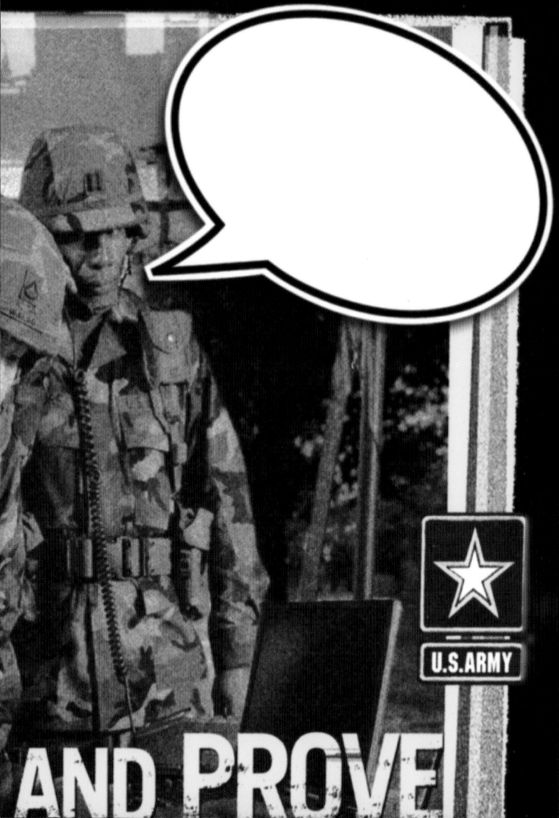

BUBBLERS

THE BUBBLE PROJECT
HAS SPREAD TO THESE COUNTRIES

AS OF JUNE, 2006

United States THEBUBBLEPROJECT.COM
United Kingdom
Italy PROGETTOBOLLA.COM
Canada
Germany
Netherlands
Australia
France
South Africa
Brazil
Spain
Mexico
Switzerland
Belgium
Hungary
Romania
Sweden
Russia
Argentina PROYECTOBURBUJA.COM.AR
Finland
Portugal
Turkey
Chile
Japan
New Zealand
Belgium
Hungary
Romania
Russia
Argentina
India

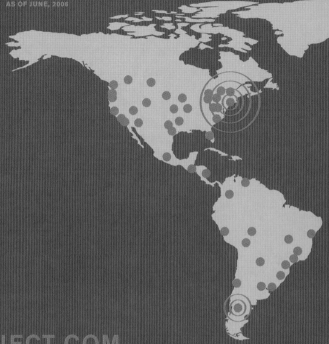

THEBUBBLEPROJECT.COM

BRING BUBBLES TO YOUR CITY

FREE ONLINE BUBBLE TEMPLATES

Download, print, cut and paste.

WORLDWIDE

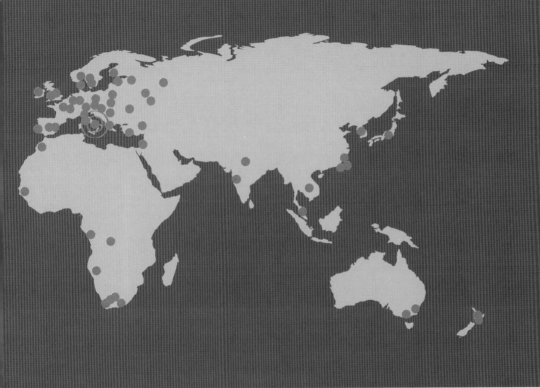

ONLINE BUBBLING

BUBBLED PERSON OF THE WEEK

Fill in your own weekly online Bubbles and e-mail them to friends.

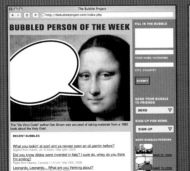

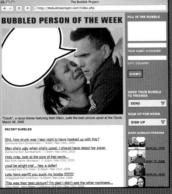

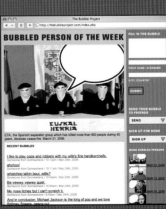

Thank you!

*NYC, Clarina Bezzola, Mom, Dad,
Stefan Sagmeister, Jeff Greenspan,
Mark Batty, Buzz Poole, Christopher Salyers,
Cory Forsyth, Mary Luria, Bob Isherwood,
Ravi Naidoo and Design Indaba,
Ze Frank, Mark Hurst and GEL, Risa Mickenberg
Maggie Hohle, Ilya Shinkar, John Putnam,
IceCreamMan.com, Jakprints.com,
Progettobolla.com (our Italian comrade),
and all Bubblers around the world!*

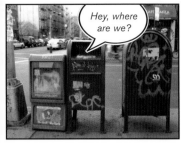
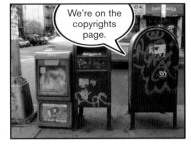
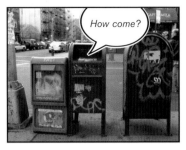

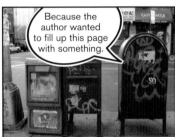
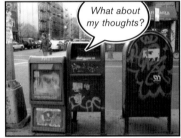

TALK BACK
THE BUBBLE PROJECT
by Ji Lee

Design and photography: Ji Lee

Editing: Buzz Poole

Production: Christopher Salyers

Back cover photography: John Putnam

Type: Impact, Akzidenz Grotesk

Printed and bound at
the National Press
The Hashemite Kingdom of Jordan

Library of Congress Control Number:
2006923831

10 9 8 7 6 5 4 3 2 1 First Edition

This edition © 2006
Mark Batty Publisher
202 West 40th Street, 5th Floor
New York, New York 10018-1504
www.talkbackbook.com

ISBN: 0-9762245-7-7

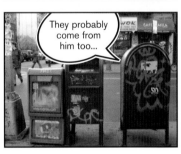
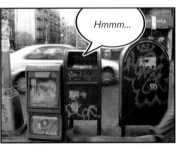

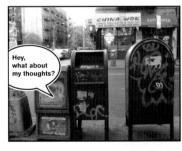

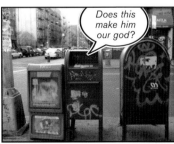
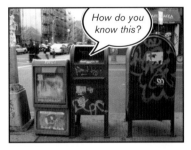
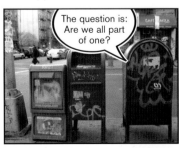

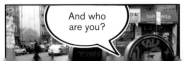

WARNING

DEFACING POSTERS AND ADS ON PUBLIC AND
PRIVATE SPACES IS VANDALISM AND AGAINST THE LAW.
OFFENDERS ARE SUBJECT TO FINES AND ARRESTS.

THE AUTHOR AND THE PUBLISHER OF THIS BOOK
DO NOT SUPPORT VANDALISM. WHATEVER YOU DO WITH
THE BUBBLE STICKERS IS 100 % YOUR RESPONSIBILITY.
SO DON'T SUE US. WE'RE NOT RICH.
HAVE FUN AND BE SAFE!

DISCLAIMER